W9-CJZ-661

More BROCHURES

ROCKPORT
PUBLISHERS

Rockport Publishers, Inc
Gloucester, Massachusetts
Distributed by North Light Books
Cincinnati, Ohio

First published in the United States of America by:
Rockport Publishers, Inc.
33 Commercial Street
Gloucester, Massachusetts 01930-5089
Telephone: (978) 282-9590
Facsimile: (978) 283-2742

Distributed to the book trade and art trade in the United States by:
North Light Books, an imprint of
F & W Publications
1507 Dana Avenue
Cincinnati, Ohio 45207
Telephone: (800) 289-0963

Other Distribution by:
Rockport Publishers, Inc.
Gloucester, Massachusetts 01930-5089

ISBN 1-56496-437-X

10 9 8 7 6 5 4 3 2 1

Production: Sara Day Graphic Design
Cover Images: (clockwise) pp. 30, 55, 26, 56, 11

Printed in Hong Kong by Midas Printing Limited.

Introduction

Brochures. They are often the first thing a graphic-designer-in-training learns how to design. They are also often what you make when learning the ropes of a new layout software program. It would be a rare case to find a graphic designer with no brochure design in his or her portfolio. But brochures are more than just training tools, and graphic designers are much more than just brochure-makers.

This collection is comprised of the best, most creative brochure designs around. From triple-fold sheets to boxes to books, every type of brochure is included. This book provides a comprehensive view of how designers are tackling the task of making notable brochure designs—so look, and be inspired.

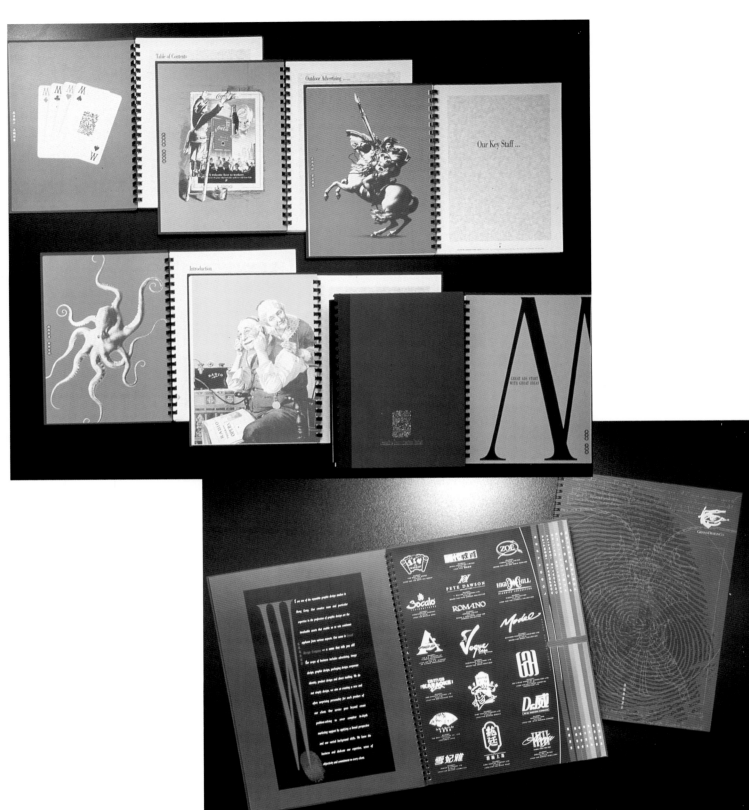

1

Design Firm **Masterline Communications Ltd.**
Art Directors **Grand So, Raymond Au,**
 Kwong Chi Man, Candy Chan
Designers **Grand So, Raymond Au, Kwong Chi Man**
Illustrators **Grand So, Kwong Chi Man**
Photographer **David Lo**
Copywriters **Grand So, Johnson Cheng**
Client **Masterline Communications Ltd.**

2➤ *The portraits on the front and inside covers are designed to reflect the intelligence and energy of the client.*

2

Design Firm **Grand Design Co.**
Art Directors **Grand So, C.M. Kwong, Raymond Au,**
 Candy Chan
Designers **Grand So, C.M. Kwong, Raymond Au**
Illustrators **Grand So, C.M. Kwong**
Photographer **David Lo**
Copywriters **Grand So, Mimi Lee**
Client **Grand Design Co.**

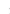

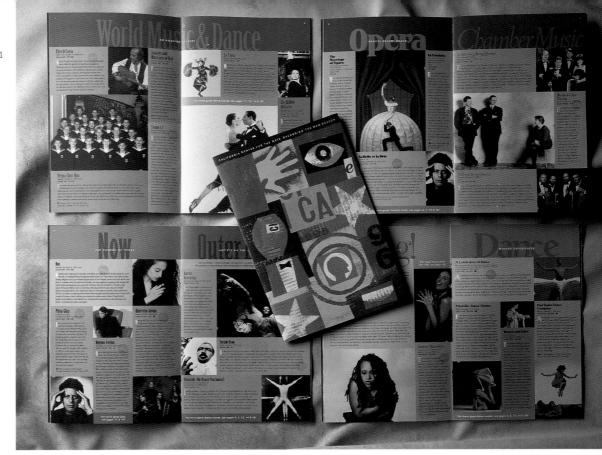

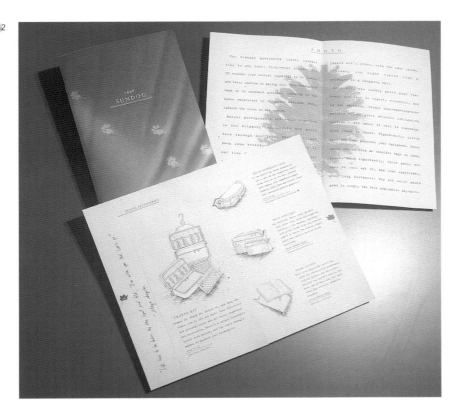

1
Design Firm **Mires Design, Inc.**
Art Director **John Ball**
Designers **John Ball and Kathy Carpentier-Moore**
Illustrator **Gerald Bustamante**
Client **California Center For The Arts, Escondido**
Tool **QuarkXPress**

1► *This 4-color brochure advertises tickets for the new season.*

2
Design Firm **Hornall Anderson Design Works, Inc.**
Art Director **Jack Anderson**
Designers **Jack Anderson, David Bates**
Illustrator **Todd Conno**
Photographer **Darrell Peterson**
Copywriter **SunDog, Inc.**
Client **SunDog, Inc.**
Paper **Recycled Paper**
Tools **Adobe Photoshop, QuarkXPress, and Macromedia FreeHand**

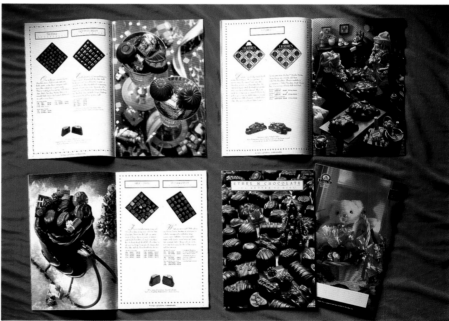

Design Firm **Mires Design, Inc.**
Art Director **Jose Serrano**
Designer **Jose Serrano**
Client **Ethel M**

The brochure was printed using a 4-color offset process.

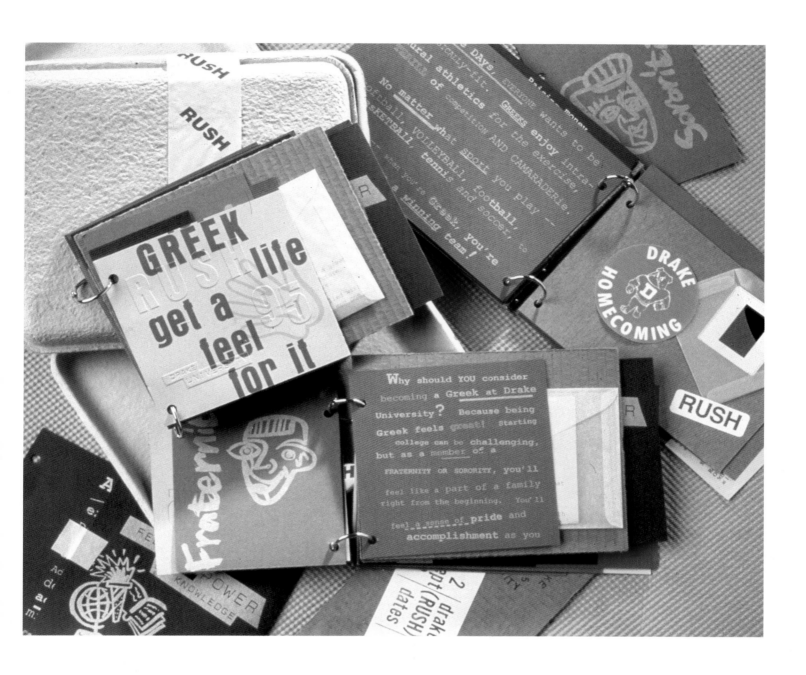

Design Firm **Sayles Graphic Design**
Art Director **John Sayles**
Designer **John Sayles**
Illustrator **John Sayles**
Copywriter **Wendy Lyons**
Client **Drake University**
Paper/Printer **Curtis Tuscan Antique, Action Print,**
 Acme Printing

For this fraternity/sorority "rush" recruitment mailing, the designer used found objects, including paper remnants from a recently completed corporate project, scrap corrugated cardboard, and industrial office supply materials. Perhaps the most innovative material found is the front cover of the piece; it is an actual metal printing plate. Although they were never actually used in the printing process, the plates have been burned with the project title "Greek Life: Get A Feel For It."

Managing the Interactive Maze SYBASE INTERMEDIA SERVER

SYBASE Intermedia Server manages the maze of systems, messages, media sources, and transactions to deliver interactive information services on demand to homes and businesses. Its open architecture provides easy integration with external applications such as subscription management systems, and interoperability with multiple video processors. Based on proven, high-performance Sybase client/server technology, SYBASE Intermedia Server is highly reliable, compatible with client/server standards, and scalable. As innovative interactive services are expanded from the trial phase to mass market audiences, SYBASE Intermedia Server will rapidly scale up to meet demands. ■ For many decades, businesses have tried to reach mass market consumers through conventional broadcast and print media. But getting a prospect's attention is a hit-or-miss proposition. Similar issues apply in business-to-business communications, because the most influential decision-makers face a blizzard of advertising, unsolicited mail, and phone calls. SYBASE Intermedia Server's ability to coordinate interactive information and manage video processors transcends the limitations of noninteractive broadcast and print media. Now the enterprise can reach its prospects through sensory-rich, "narrowcasting" interactions that target each individual user on the basis of preferences, past transactions, or realtime interactions.

The SYBASE Intermedia Server is the integration and management component of the SYBASE Intermedia architecture. It is deployed in a networked environment to support the following major functions:

■ Storage and management of information about content, services, subscribers, and applications

■ Coordination of messages among client applications, content sources, and back-end subscription management systems for billing and pricing

■ User authorization and access control for systems, services, applications, and content stored throughout the interactive environment

■ Logging of all events in persistent storage to enable offline business system transaction processing

■ Basic application templates for video services, shopping services, and anonymous services

■ Management of service transitions, including failover, and context restoration

Managing the Interactive

SYBASE Intermedia Server manages the m messages, media sources, and transactions to d tive information services on demand to hom nesses. Its open architecture provides easy integ external applications such as subscription ma systems, and interoperability with multiple video p Based on proven, high-performance Sybase clien technology, SYBASE Intermedia Server is highly re compatible with client/server standards, and scalabl innovative interactive services are expanded from the phase to mass-market audiences, SYBASE Intermedia Ser will rapidly scale up to meet demands. ■ For many decade businesses have tried to reach mass market consumers

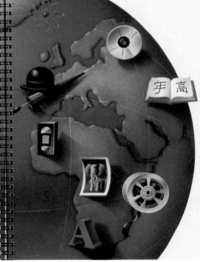

The SYBASE Intermedia Server is the integration and management component of the SYBASE Intermedia architecture. It is deployed in a networked environment to support the following major functions:

■ Storage and management of information about content, services, subscribers, and applications

■ Coordination of messages among client applications, content sources, and back-end subscription management systems for billing and pricing

■ User authorization and access control for systems, services, applications, and content stored throughout the interactive environment

■ Logging of all events in persistent storage to enable offline business system transaction processing

■ Basic application templates for video services, shopping services, and anonymous services

■ Management of service transitions, including failover, and context restoration

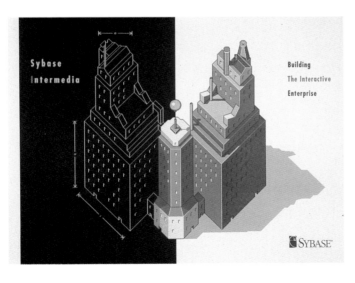

Sybase Intermedia

Building The Interactive Enterprise

SYBASE

Design Firm **Gordon Mortensen Design**
Art Director **Gordon Mortensen**
Creative Director **Andrea Bryck**
Designers **Gordon Mortensen, David Stuhr**
Illustrators **John Craig, Glenn Mitsui, John Bleck, Ron Chan, Hiro Kimura, Theo Rudnak**
Copywriters **Bob Runge, Gary Seeman**
Client **Sybase, Inc.**

Objective: To produce a brochure that would inform software developers about the client's interactive products

Innovation: To emphasize the interactive nature of the client's product, the designers created several interactive pages for this brochure. To illustrate the perception that corporations can extend their business globally, for example, a pull-out page reveals prospective growth as the page is opened. Carefully placed die-cuts also display interesting views before the pages are turned, as well as after.

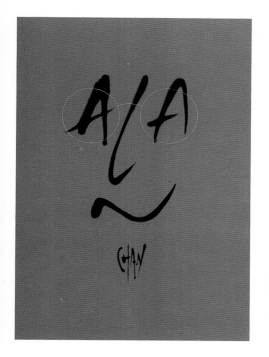

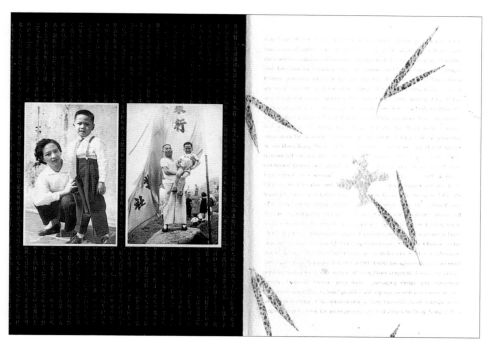

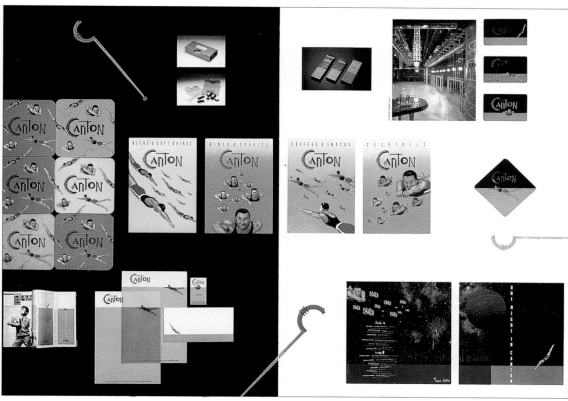

Design Firm **Alan Chan Design Co.**
Art Director **Alan Chan**
Designer **Alan Chan/Phillip Leung/Peter Lo**
Photographer **Sandy Lee/Johnny Koo**
Copywriter **Hillery Binks**
Client **Alan Chan Design Co.**

Five colors on art card, art paper

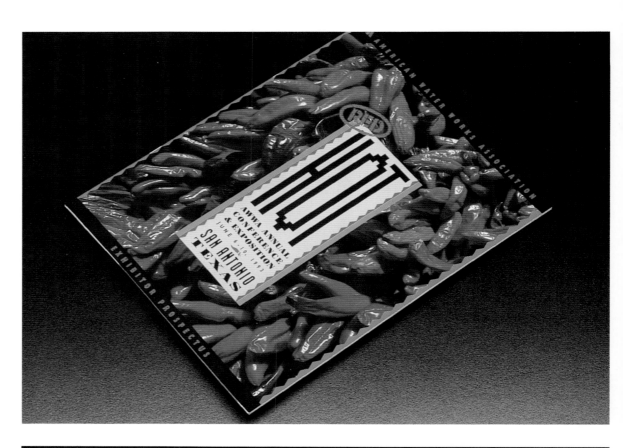

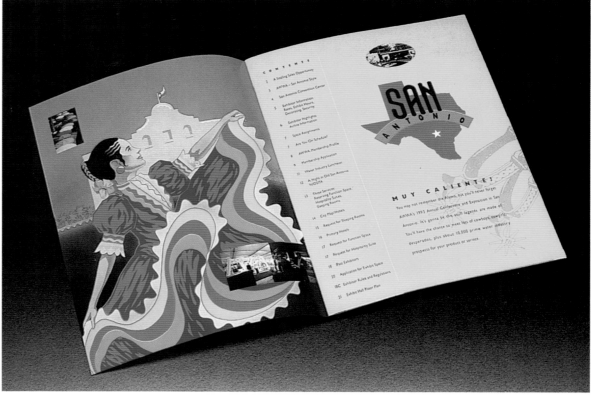

1
Design Firm **Lee Reedy Design Associates, Inc.**
Art Director/Designer **Lee Reedy**
Photographer **Brad Bartholomew (cover)**
Copywriter **John Kaiser**
Client **American Water Works Association**
Printing **4-color**

2
Design Firm **Lee Reedy Design**
Art Director **Lee Reedy**
Designer **Lee Reedy**
Illustrator **Mathew McFarren**
Photographer **Dan Sidor**
Copywriter **Bill Holshevnikoff**
Client **Chimera**
Paper/Printer **LOE, Communigraphics**
Tools **QuarkXPress and Macromedia FreeHand**

CHIMERA

CHIMERA

CHIMERA

PHOTOGRAPHIC LIGHTING 1994·95

CHIMERA

Light, Made by Hand

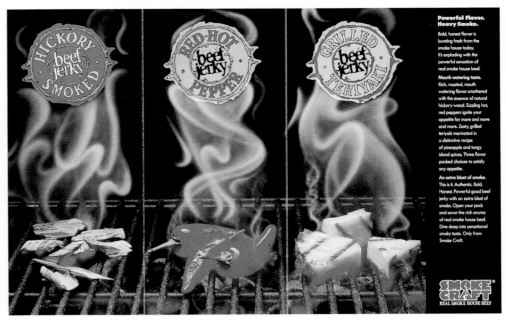

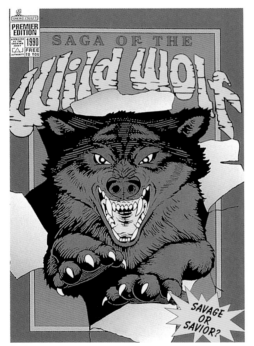

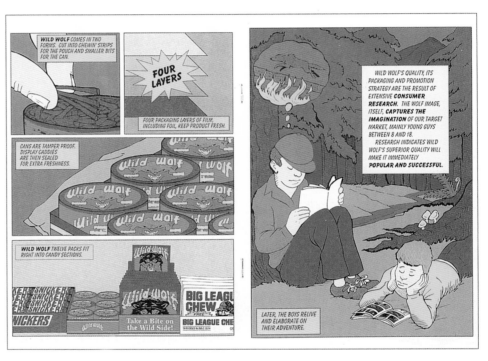

1
Design Firm **Creative Co., Inc.**
Art Director **Jennifer Larsen Morrow**
Designer **Cathie Von**
Photographer **Mike Dahlstrom**
Copywriter **Michael Perman**
Client **Curtis Burns Meat Snacks**

Four colors plus on 80-lb. Glass cover (premium)

2
Design Firm **Creative Co. Inc.**
Art Director **Jennier Larsen Morrow**
Designer **Mike Satern/Laura Trammel**
Illustrator **Barry Nichols**
Copywriter **Michael Perman**
Client **Curtis Burns Meat Snacks**

*Four colors on 80-lb. Productolithe book glass (cover)
and Hammermill book vellum white opaque 70-lb.
(inside)*

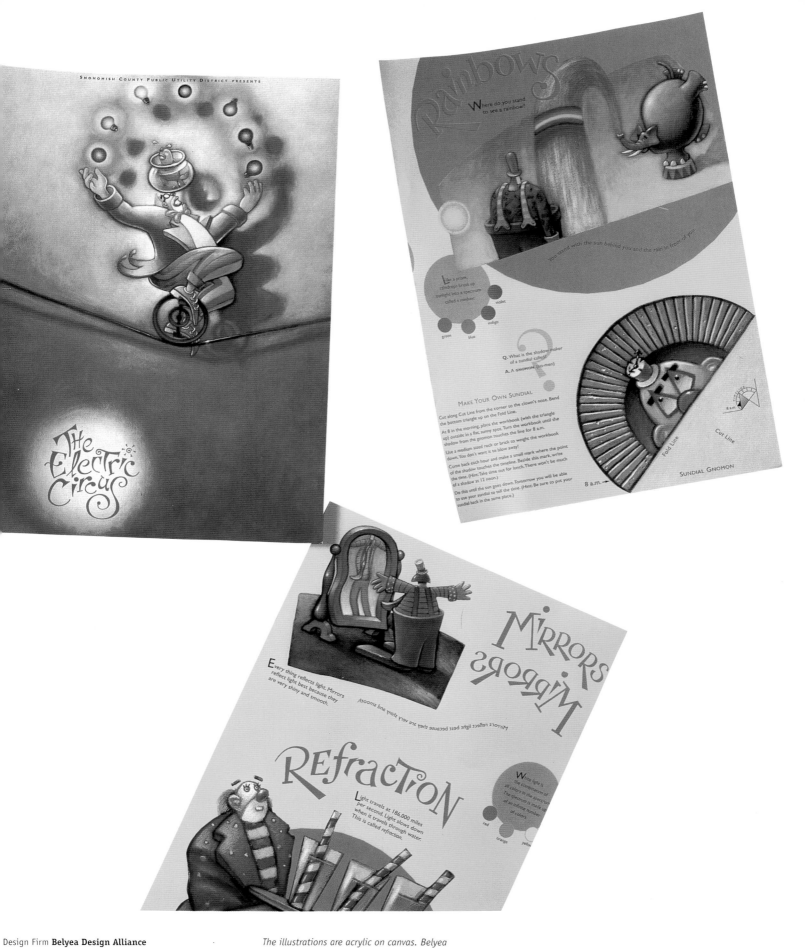

Design Firm **Belyea Design Alliance**
Art Director **Patricia Belyea**
Designer **Samantha Hunt**
Illustrator **Jere Smith, Brian O'Neill**
Calligrapher **Christian Salas**
Copywriters **Peggy Willcats and Luann Columbo**
Client **Snohomish County Public Utility District**
Paper/Printer **Springhill 12 pt, Allied Printers**
Tools **QuarkXPress and Macromedia FreeHand**

The illustrations are acrylic on canvas. Belyea Design Alliance produced the lettering by hand and completed the final piece in QuarkXPress and Macromedia FreeHand. The built-in sundial has a perforation and a score for the three-dimensional shadow maker.

THE GRAND TOUR

Tourist Delivery Program

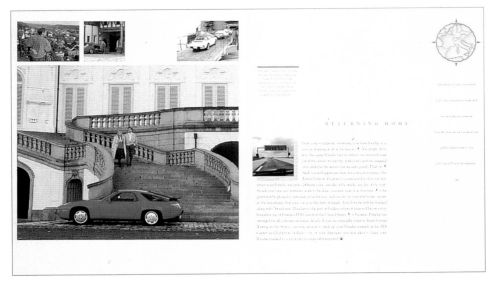

RETURNING HOME

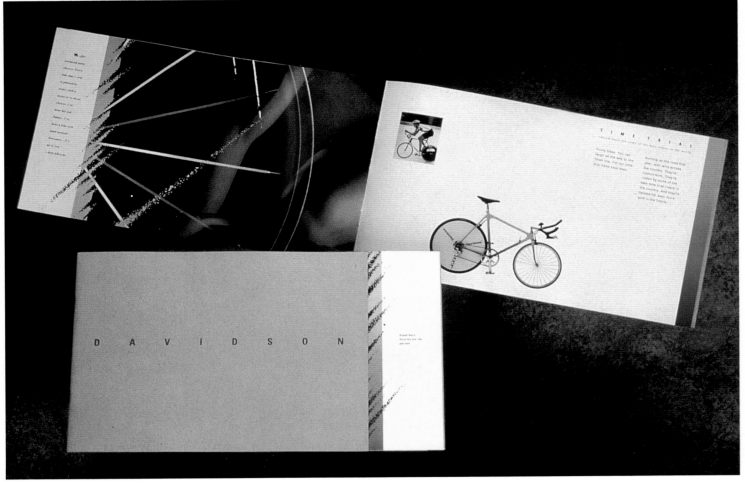

DAVIDSON

1
Design Firm **Hornall Anderson Design Works**
Art Director **Luann Bice**
Designer **Luann Bice**
Illustrator **Heidi Hatlestad, Mary Hermes**
Photographer **Kai Scheufler**
Copywriter **David McFadden**
Client **Porsche Cars North America**

2
Design Firm **Hornall Anderson Design Works**
Art Director **Jack Anderson**
Designer **Jack Anderson, Jani Drewfs,**
 Mary Hermes
Illustrator **David Bates, Scott McDougall**
 (airbrush)
Photographer **Tom Collicott**
Copywriter **Pamela Mason-Davey**
Client **Davidson Cycles**

Six colors on Kraft Centura

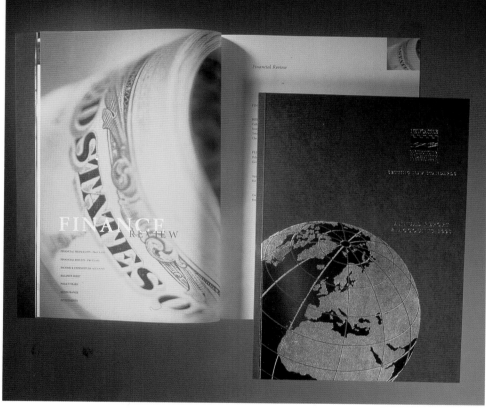

Design Firm **Yellow M**
Art Director **Craig Falconer**
Designer **Craig Falconer**
Photographer **Tony Stone Images**
Client **New Castle Protection Indemnity Association**
Paper **Keaycolour, Matte Art**
Tools **Macromedia FreeHand, QuarkXPress,
 and Adobe Photoshop**

This annual report focuses on three areas—direction, support, and finance—and illustrates each with a photograph. The front cover uses foil blocking on colored card. The foil is applied full strength and a thirty percent tint creates a two-tone foil effect.

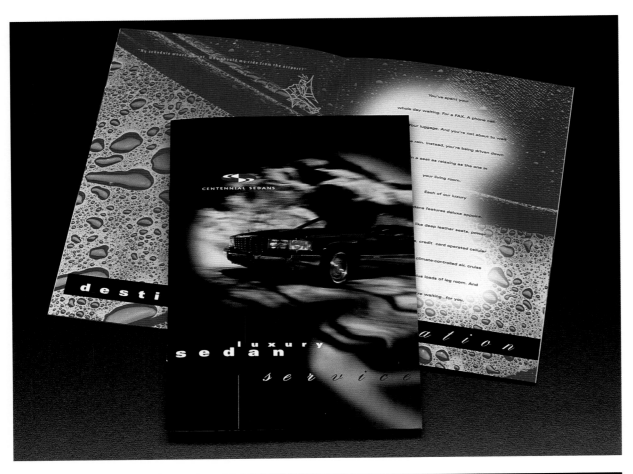

1
Design Firm **Lee Reedy Design**
Art Director **Lee Reedy**
Designer **Karey Christ-Janer**
Illustrator **Karey Christ-Janer**
Photographer **Howard Sokol**
Copywriter **Janet Aitken**
Client **Centennial Sedans**
Paper/Printer **Lustrocoat, Phoenix Press**
Tools **QuarkXPress and Adobe Photoshop**

2
Design Firm **Lee Reedy Design**
Art Director **Lee Reedy**
Designers **Heather Haworth and Kathy Thompson**
Illustrator **Heather Haworth**
Client **National Ski Patrol**
Printer **Knuntsen Printing, Lange Graphics**
Tool **QuarkXPress**

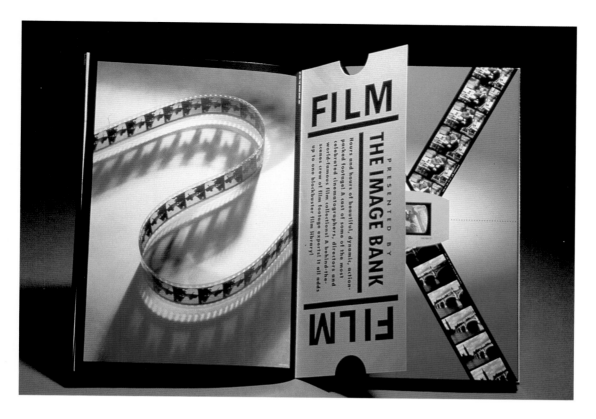

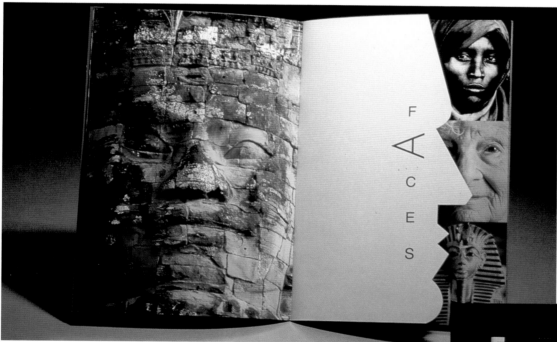

Design Firm **Sibley/Peteet**
Art Director **David Beck**
Designer **David Beck**
Client **The Image Bank**

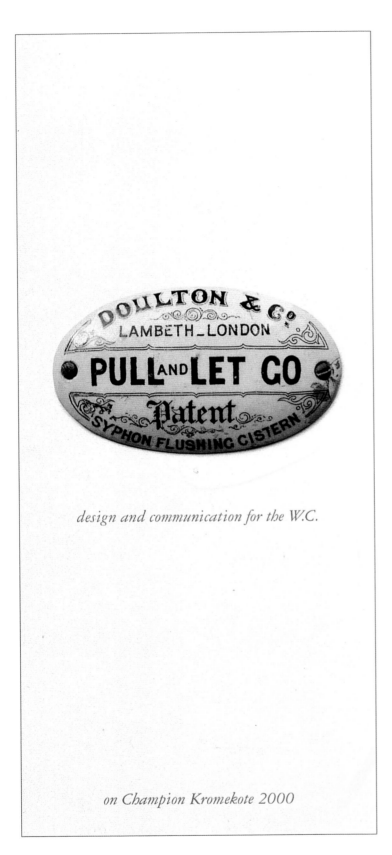

design and communication for the W.C.

on Champion Kromekote 2000

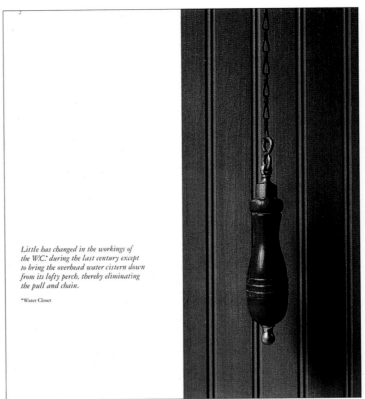

Little has changed in the workings of the W.C. during the last century except to bring the overhead water cistern down from its lofty perch, thereby eliminating the pull and chain.*

*Water Closet

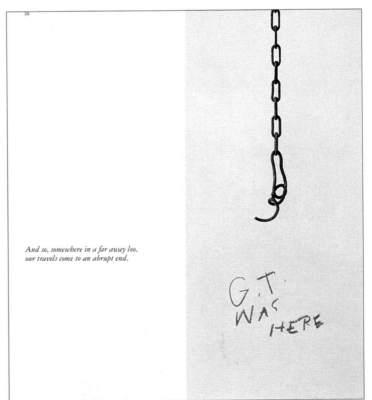

And so, somewhere in a far away loo, our travels come to an abrupt end.

Design Firm **George Tscherny, Inc.**
Art Director **George Tscherny**
Designer **George Tscherny**
Photographer **George Tscherny**
Copywriter **George Tsherny**
Client **Champion International**

Six colors on Champion Kromekote 2000

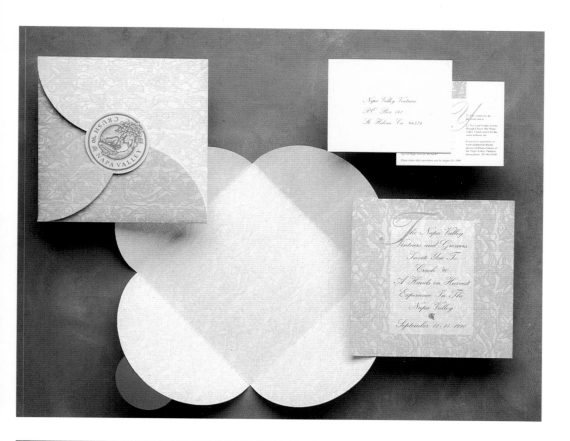

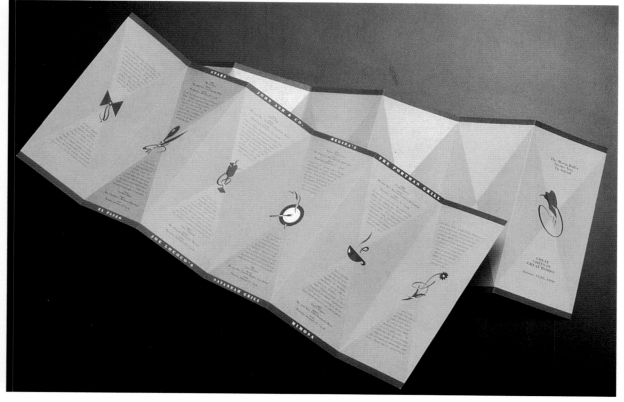

1
Design Firm **Colonna, Farrell: Design Associates**
Art Director **Tony Auston**
Designer **Tony Auston**
Illustrator **Mike Gray**
Client **Napa Valley Vintners Association**

Two PMS colors on Speckletone

2
Design Firm **Sackett Design**
Art Director **Mark Sackett**
Designer **Mark Sackett**
Illustrator **Mike Takagi**
Client **Marin Ballet**

Three colors on 100-lb Quintessence dull

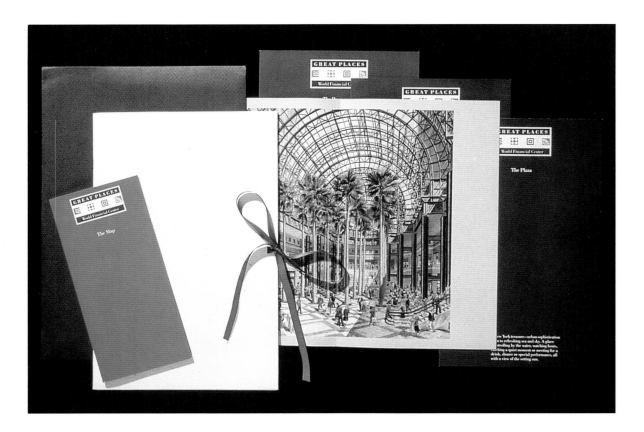

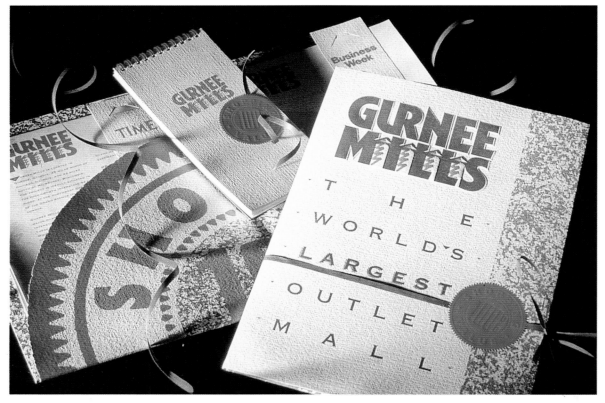

1
Design Firm **Donovan and Green**
Art Director **Michael Donovan**
Designer **Michael Donovan, Jenny Barry, Barbara Tanis, Clint Morgan**
Illustrator **Carlos Diniz**
Photographer **Peter Aaron, Neil Selkirk**
Copywriter **David Borstin, Jim Kiewel**
Client **Olympia & York Retail Development Co.**

Five colors and two varnishes on 100-lb. Ikonorex dull

2
Design Firm **Communication Arts, Inc.**
Art Director **Henry Beer**
Designer **David A. Shelton**
Client **Western Development Corp.**

Three colors on Speckletone Cordtone Naturalcover

Registered emboss on cover with clear foil.

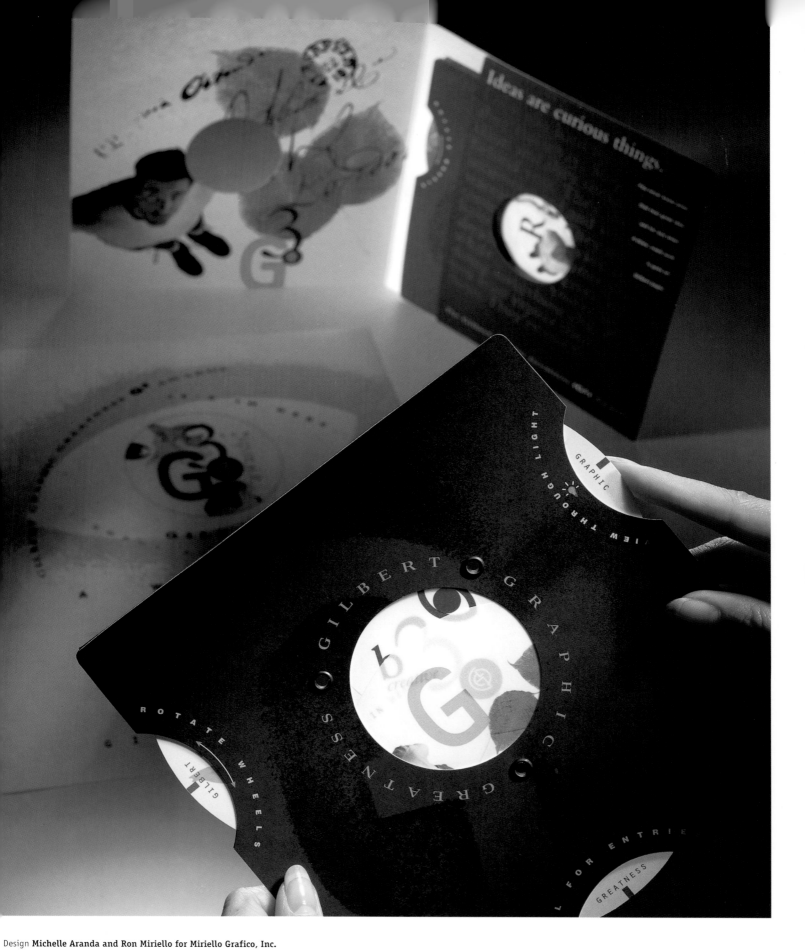

Design **Michelle Aranda and Ron Miriello for Miriello Grafico, Inc.**
Project **Gilbert G3 Awards**
Client **Gilbert Paper Company**
Tools **Adobe Illustrator, Adobe Photoshop on Macintosh**
Fonts **Bembo, Helvetica, ITC Kabel**

*To reinvigorate the awards program, a call-for-entries brochure
using a turning-wheel design of type and photo images allows
for endless combinations.*

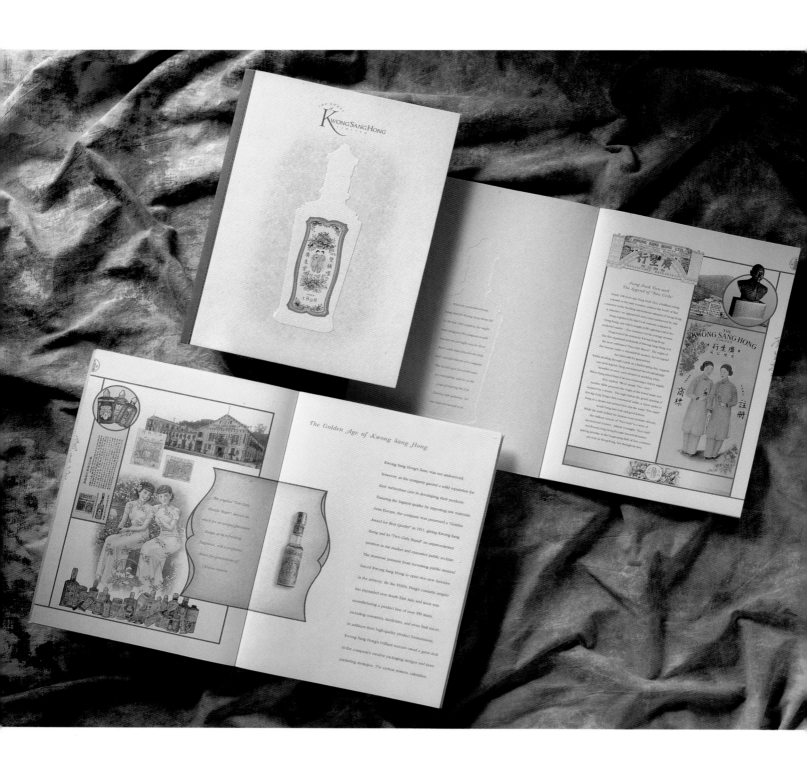

Design Firm **Kan Tai-keung Design & Associates Ltd.**
Art Directors **Kan Tai-keung, Freeman Lau Siu Hong,**
 and Eddy Yu, Chi Kong
Designer **Joyce Ho Ngai Sing**
Copywriter **The House of Kwong Sang Hong Ltd.**
Client **The House of Kwong Sang Hong Ltd.**
Paper/Printer **Graphika, Woodfree Paper, Yu Luen**
 Offset Printing Fty. Ltd.
Tools **Adobe Photoshop, Macromedia FreeHand**

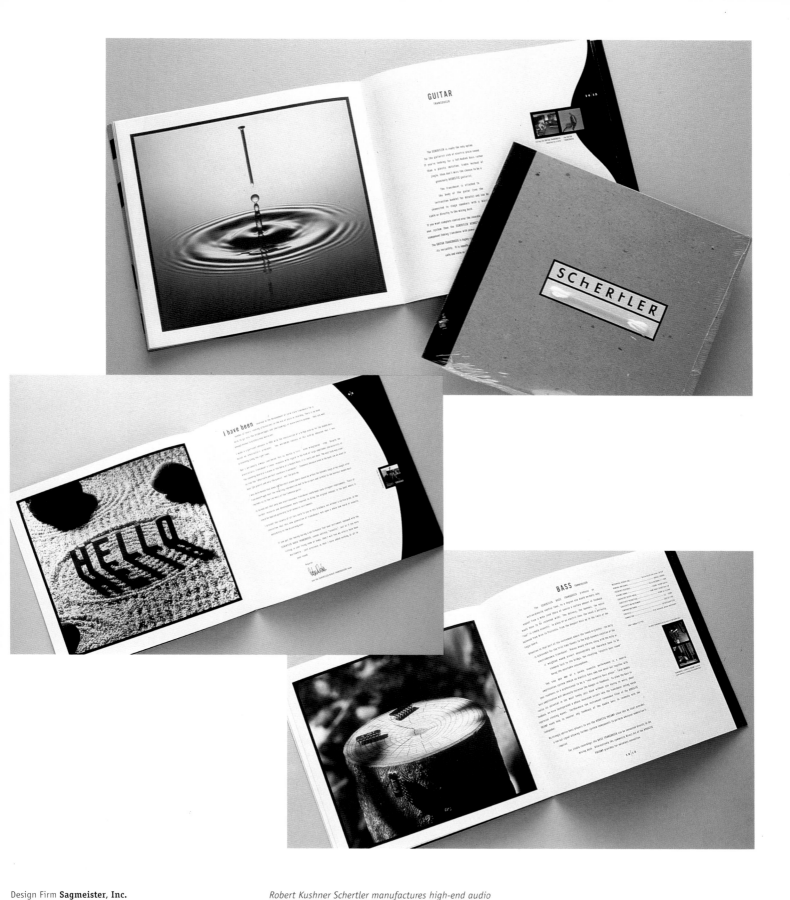

Design Firm **Sagmeister, Inc.**
Art Director **Stefan Sagmeister**
Designers **Stefan Sagmeister and Eric Zim**
Illustrator **Eric Zim**
Photographer **Tom Schierlitz**
Copywriter **Stephan Schertler**
Client **Schertler Audio Transducers**
Paper/Printer **80 lb. Matte Coated, Cover Chipboard**

Robert Kushner Schertler manufactures high-end audio pick-ups for acoustic instruments. Their logo is made up of concentric ellipses. Each chapter shows a photographic presentation of the logo.

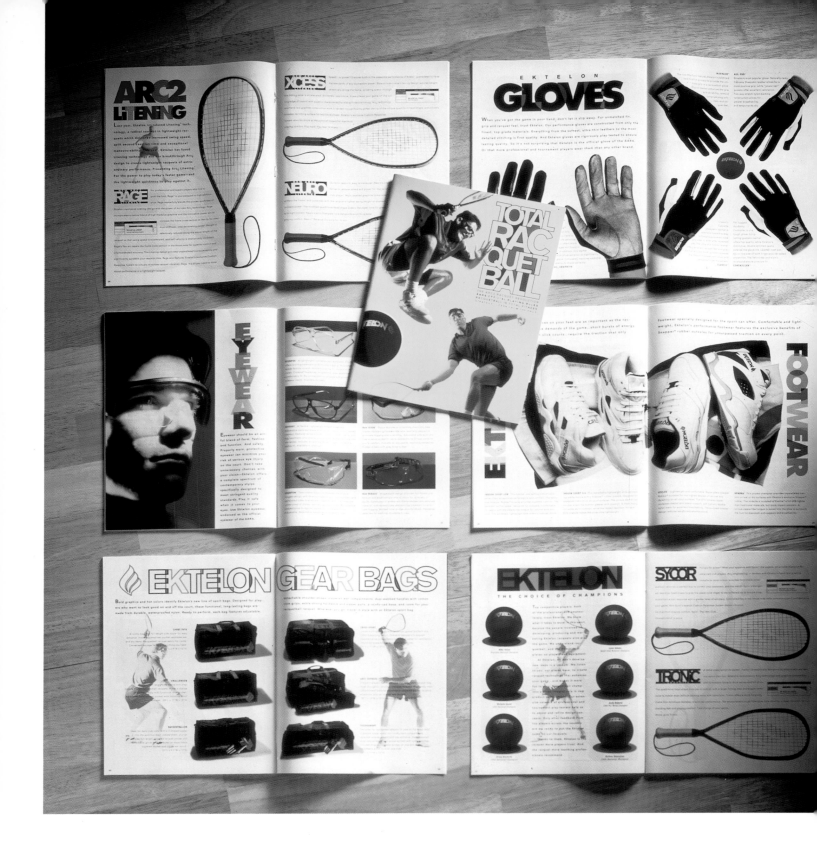

Design **Jose A. Serrano for Mires Design, Inc.**
Project **Total Racquetball 1994**
Client **Ektelon**
Tools **Adobe Illustrator, Adobe Photoshop on Macintosh**

*Total Racquetball is an annual publication that features the client's
entire line of products, articles, tips on nutrition and on how to
improve one's game, interviews with pros, and so on. The type was
selected because it conveyed a sportslike attitude.*

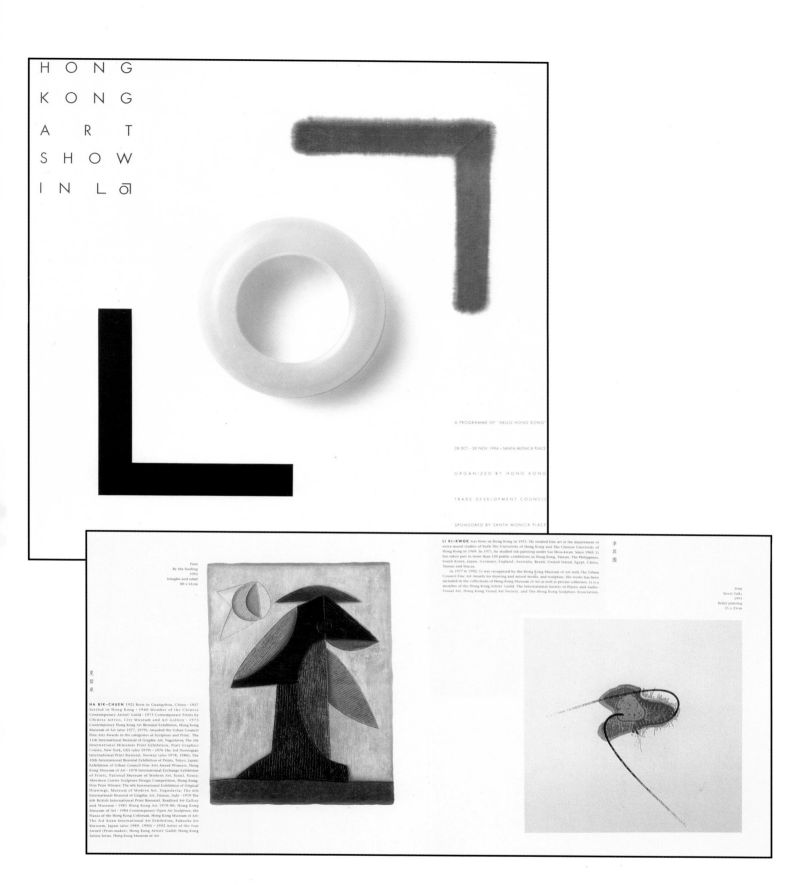

Design Firm **Bernhardt Fudyma Design Group**
Art Director **Craig Bernhardt**
Designer **Janice Fudyma**
Illustrator **James Yang**
Copywriter **Jerry Mosier**
Client **Hibbard Brown**
Printer **Quality House of Graphics**
Tool **QuarkXPress**

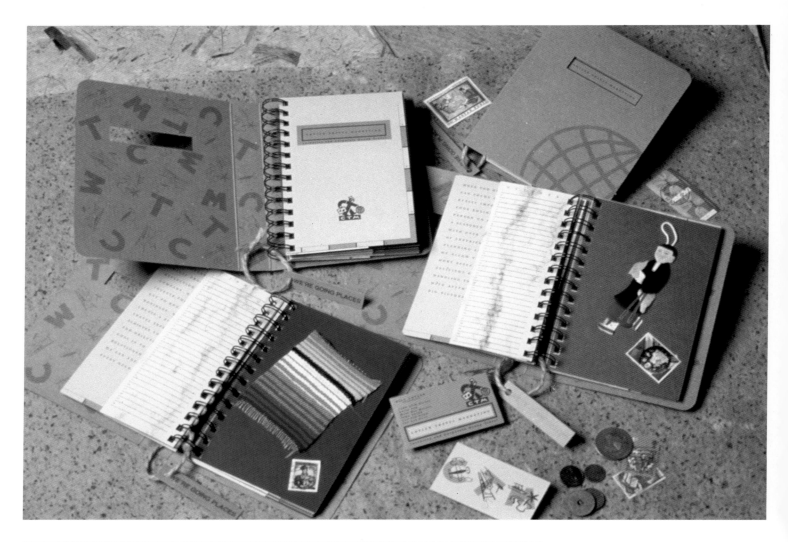

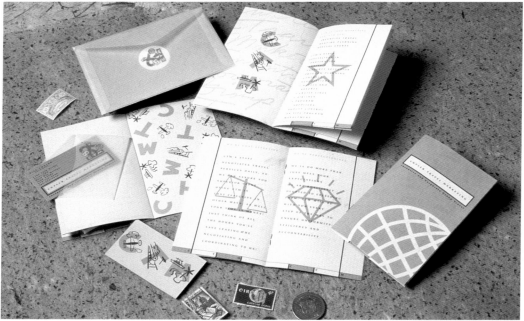

Design Firm **Sayles Graphic Design**
Art Director **John Sayles**
Designer **John Sayles**
Illustrator **John Sayles**
Copywriter **Wendy Lyons**
Client **Cutler Travel Marketing**
Paper/Printer **Curtis Paper, Artcraft Printing,
 The Printing Station**

Printed on text weight paper to save costs, the introductory brochure mails in a glassine envelope. The corporate brochure is a three-dimensional encounter—with foreign coins and stamps, postcards, maps, and travel memorabilia from around the globe, attached by hand to its multi-colored pages.

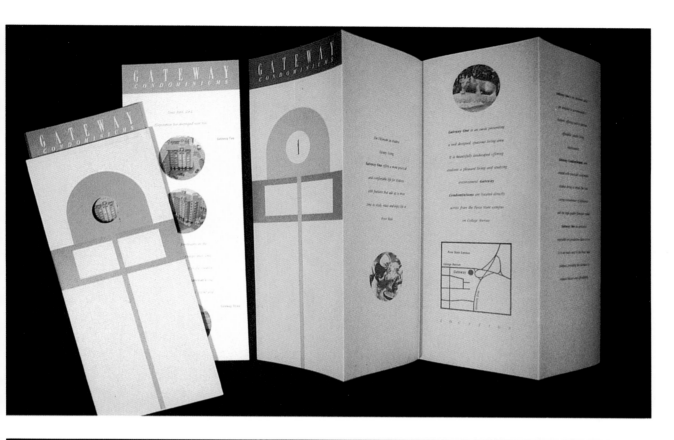

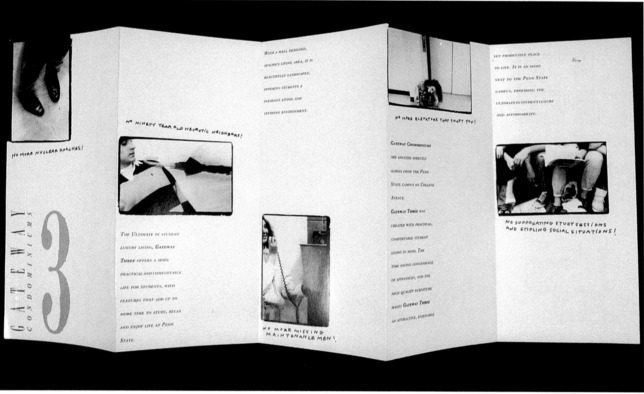

1
Design Firm **Sommese Design**
Art Director **Lanny Sommese, Kristin Breslin**
Designer **Kristin Breslin**
Photographer **Lanny Sommese**
Client **HFL Corp.**

Four process colors with a one-color insert

The cover motif on the folder is taken from architectural details of the building. A circular die-cut is punched through the cover to expose a photo of the architect's model of the building.

2
Design Firm **Sommese Design**
Art Director **Kristin Breslin**
Designer **Kristin Breslin**
Photographer **Kristin Breslin**
Copywriter **Kristin Breslin**
Client **HFL Corp.**

Three colors

1

Design Firm **Lee Reedy Design**
Art Director **Lee Reedy**
Designer **Heather Haworth**
Illustrator **Heather Haworth**
Copywriter **Suzy Patterson**
Client **Mares**
Paper/Printer **Lithofect, Phoenix Press**
Tools **QuarkXPress**

1➤ *The photos were scanned and then manipulated and colorized in Adobe Photoshop. The figure is from the "Big Cheese" Emigre font.*

2➤ *The images for this brochure were scanned and then colorized.*

2

Design Firm **Lee Reedy Design**
Art Director **Lee Reedy**
Designer **Kathy Thompson**
Photography **Stock**
Client **Hewlett-Packard**
Paper/Printer **Speckletone, Center Printing**
Tools **QuarkXPress and Adobe Photoshop**

The Multimedia Market is Growing at an Incredible Rate! In 1990, the multimedia market was in an early growth stage, accounting for approximately $4 billion in sales. By 1995, it's expected to increase to almost $25 billion* – a growth of over 600% in five years! This represents huge profit potential for value-added resellers. And NOW is the time to take full advantage of this opportunity. How can you get a piece of the action?

The IBM Ultimedia Tools Series: Nearly 100 Products — 1 Common Architecture

IBM is a recognized leader in multimedia technology, the only full-service provider of multimedia and creative graphics products and services in the country. From training and support to full multimedia systems integration such as video servers and software, IBM understands your customers' needs. Supplemented by an aggressive industry wide marketing, advertising and public relations program, IBM creates the marketing presence to bring your customers back — and your profits soaring.

Source: FROST & SULLIVAN

IBM's expanding Ultimedia Tools Series offers your customers easy entry into the creative graphics arena by providing one common, open architecture for all participating software manufacturers — ensuring that any and all tools will work together with ease. This architecture is unique as it was created by participating Ultimedia Tools Series developers, and not a third party. Whenever possible this ever evolving architecture adheres to existing industry standards. The architecture gives end-users limitless computer graphics capabilities to enhance business communications using the OS/2™, Windows™ and DOS systems they already have. You can also integrate entire systems for your customers to create a complete creative graphics solution!

The Profit Opportunity – Access Graphics and Ultimedia Tools Series

Let Access Graphics show you how the Ultimedia Tools Series can increase your bottom line by offering your customers a full spectrum of unique, easy-to-use products, by expanding your markets, and by providing all the support you need!

Increase Sales with Products that are Faster and Easier

With the Ultimedia Tools Series, you can offer all of your customers interested in multimedia an easy, efficient way of satisfying all their creative graphics needs. As a result of the Ultimedia Tools Series' common architecture, casual to professional users can introduce, demonstrate and sell their products and services; train personnel; hold impromptu video conferences and two-way meetings; improve everything from memos to major presentations; increase productivity and lower communications costs plus much more . . all faster and easier than they've ever imagined!

Expand Your Markets

Expand your markets with the Ultimedia Tools Series by entering some of the most exciting areas in the creative graphics industry today, including desktop video, authoring, graphic design, audio and animation. Increase your profits by increasing your customer base!

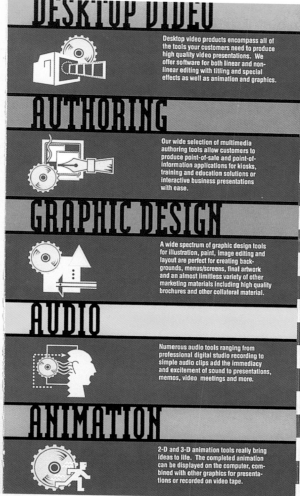

DESKTOP VIDEO

Desktop video products encompass all of the tools your customers need to produce high quality video presentations. We offer software for both linear and non-linear editing with titling and special effects as well as animation and graphics.

AUTHORING

Our wide selection of multimedia authoring tools allow customers to produce point-of-sale and point-of-information applications for kiosks, training and education solutions or interactive business presentations with ease.

GRAPHIC DESIGN

A wide spectrum of graphic design tools for illustration, paint, image editing and layout are perfect for creating backgrounds, menus/screens, final artwork and an almost limitless variety of other marketing materials including high quality brochures and other collateral material.

AUDIO

Numerous audio tools ranging from professional digital studio recording to simple audio clips add the immediacy and excitement of sound to presentations, memos, video meetings and more.

ANIMATION

2-D and 3-D animation tools really bring ideas to life. The completed animation can be displayed on the computer, combined with other graphics for presentations or recorded on video tape.

The Access Graphics Advantage– All the Support You Need

Ultimedia Tools Series products are distributed through Access Graphics, and right now you can become authorized to sell these products and participate in the greatest growth potential in the industry today. Access Graphics offers a host of complementary peripherals to complete an Ultimedia Tools Series solution, including products from top-name manufacturers such as IBM, Sony, Mitsubishi, Truevision and Hewlett-Packard.

What's more, we'll help you. When you sign up with Access Graphics to sell the products of the Ultimedia Tools Series, we'll provide you with all the support you need. Like an expert sales staff. Technical support and training. Complementary solution products. Marketing tools. And more. Access provides all this support free of charge, allowing more revenue to flow to your bottom line.

In addition, when you request authorization materials, we'll send you our free authorization kit, complete with a multimedia Sampler CD of the Ultimedia Tools Series products, configuration guide, product matrix and our Creative Graphics application form.

FAX FORM

COMPANY

NAME

PHONE

FAX

Don't wait... the multimedia market is exploding and NOW is the time to realize its profit potential! Call your Access Graphics account manager for more information at

1-800-733-9333

or Fax the above form to (303) 440-1681.

1

Design Firm **Lee Reedy Design**
Art Director **Lee Reedy**
Designer **Lee Reedy**
Copywriter **Access Graphics**
Client **Access Graphics**

Printing, 4-color

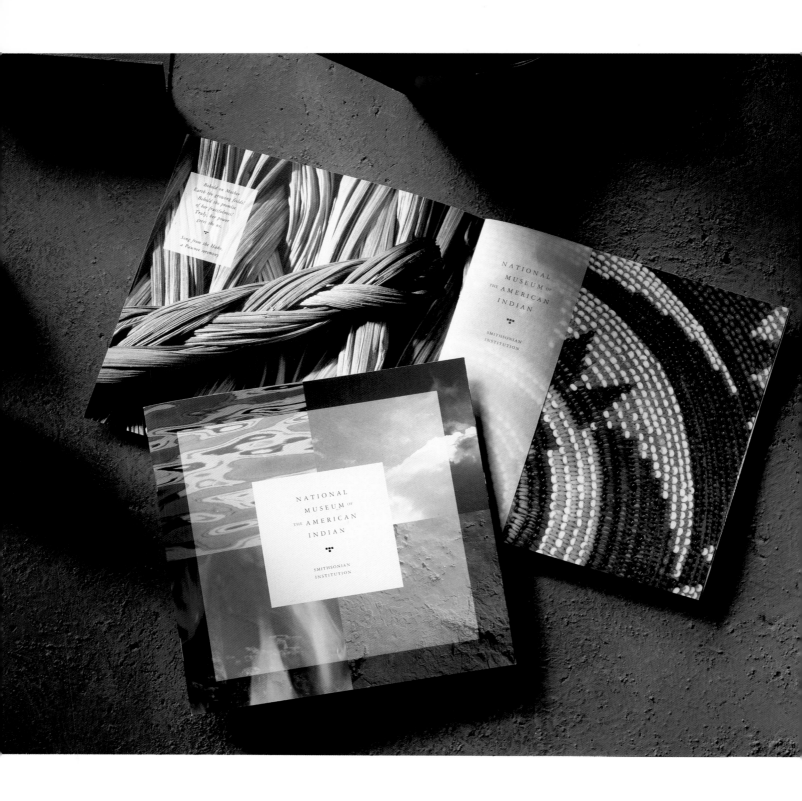

Design Firm **Grafik Communications, Ltd.**
Designers **Lynn Umemoto and Judy Kirpich**
Photographer **David Heald**
Client **National Museum of the American Indian**
Printer **Virginia Lithograph**
Tool **QuarkXPress**

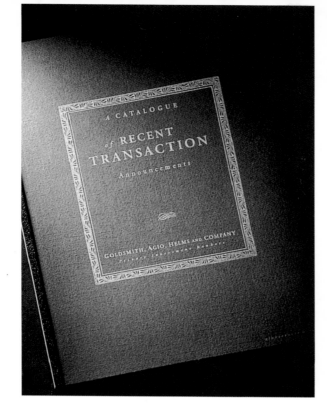

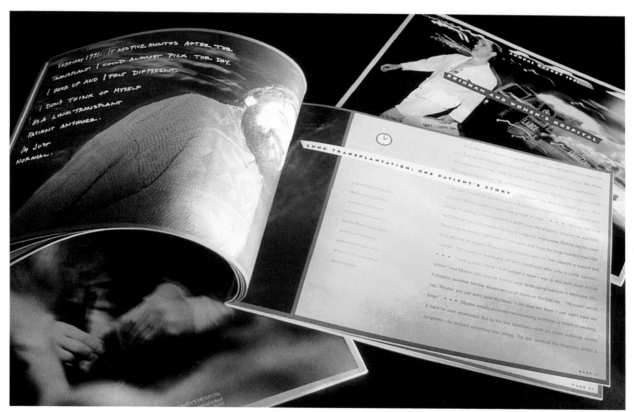

1
Design Firm **Olson Johnson Design Co.**
Designer **Dan Olson/Haley Johnson**
Client **Goldsmith, Agio, Helms & Co.**
Printing **3-color on Gilbert Esse French Parchtone**

2
Design Firm **Clifford Selbert Design**
Design Team **Clifford Selbert/Melanie Love**
Photographer **Jerry Berndt**
Copywriter **Susan Reed**
Client **Brigham and Women's Hospital**
Printing **Starwhite Vicksburg (pages), Golden Cask Dull (cover)**

*Design team was on call to observe an actual transplantation. They
wanted to achieve the same "immediacy" in the brochure design.*

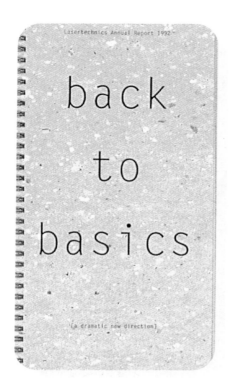

Lasertechnics Annual Report 1992

back
to
basics

[a dramatic new direction]

Lasertechnics designs, manufactures and markets laser coding systems and digital image printers for use in industry. Our goal is to maximize shareholder value by leveraging technological know-how into commercial solutions, and by continually broadening the markets for our products around the world.

Letter from The Office of the Chairman

Dear Shareholders,

Lasertechnics took a firm new direction in 1992. The Board of Directors appointed Eugene A. Bourque as President and created a special management committee to oversee operations. It is comprised of Bourque, Chairman of the Board and CEO Richard M. Clarke, and Vice Chairman Harrison H. Schmitt. These changes were made after the resignation of Louis F. Bieck, Jr., former president and chief executive officer.

Our new management committee quickly refocused the efforts of all Lasertechnics employees on what the company does best. We went back to basics. We terminated our lease obligations on our old California facility, and sold or discontinued products that had reached the end of their productive life cycles. For example, our Fizeau wavelength meter, which we had sold for more than nine years, was not selling against better products with lower prices, and so we discontinued it. We also sold both the technology and service interest in our beam directed lasers to Hai Tech Electro-Optics, Inc., a California company. Furthermore, we discontinued the refurbishing business for the Blazer™ 5000, and concentrated

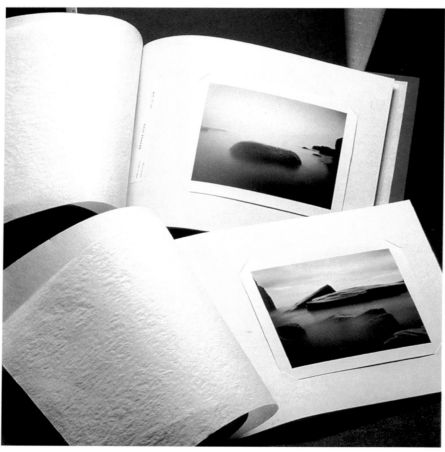

1
Design Firm **Vaughn Wedeen Creative**
Art Director **Steve Wedeen**
Designer **Steve Wedeen**
Copywriter **Nathan James**
Client **Lasertechnics, Inc.**
Printing **French Durotone (packing carton), French Speckletone Kraft (cover), Simpson LaMonte Basketweave Gray Safety Paper**

2
Design Firm **Olson Johnson Design Co.**
Designer **Haley Johnson**
Photographer **George Peer**
Client **Jane Jenni/Representative**
Printing **1-color on French Durotone Blueridge Board**

"The Crowd" is the culminating work of a long series of street scenes. But here the passers-by assume a new role as members of humanity and the union of people is in itself the theme

The movement of a crowd is one of unparalleled continuous metamorphoses — a prerequisite for sculpture I believe. Fascinating like a procession of clouds or ocean waves the diabolical dance of flames, the crowd, by its human significance, transcends all these to attain drama.

A link with my sculptured landscapes and their defts and crevices seems possible but the oceanic world is also present. A sea of people. However I am first and foremost a city-dweller and the constant throng of my fellow-beings is my daily bread.

Raymond Mason

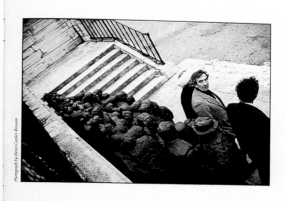

Photograph by Henri Cartier-Bresson

Raymond Mason has great thumbs for sculpture, smashed flat and bent double back from countless days of plying, gouging and smoothing material into form. Mason's primary material is plaster, and in his hands it can become anything. He mixes it in half of a rubber ball, obtained from a toy vendor in the park near his Paris studio. The studio is a white world filled with monumental work in progress. Soft light from the overhead skylight fills the space. Plaster dust like freshly fallen snow covers the floor. Anyone leaving the studio must carefully wipe his feet. For Mason, plaster is the solution for every problem, from mending the skylight to binding his armatures together. In his hands, plaster magically becomes delicate lettuce leaves or bruised fruit, punched in faces of an anonymous crowd or branches of a near life-size tree. — Sometimes when he has chosen to abandon bronze and the job of modeling is complete, Raymond puts away his plaster and rubber mixing ball and wheels in a cart loaded with many jars of multi-colored vinyl paint. My fantasy is that he arms himself with brushes, goes to the electrical board of his studio/laboratory and pulls down on the handle of a giant circuit switch à la Dr. Frankenstein. It sends a super-charged volt of pure color onto the first plaster shapes. — Raymond the artist/inventor is driven with excitement, adding more color everywhere: to noses, hats, elbows, crotches, cobblestones, chimneys, window pots, fists, armpits, clouds. At this point Raymond, who in addition to his sculptor's hands and painter's eye possesses a

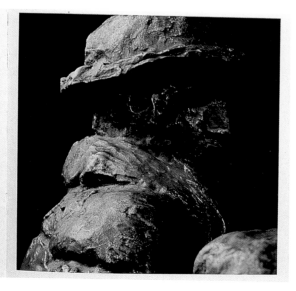

Design Firm **Patterson Wood Partners**
Art Director **Tom Wood**
Designer **Tom Wood**
Photographer **Gloria Baker**
Copywriter **Mary Anne Costello**

Three colors and metallic on Warren LOE

THE RIGHT PLAN

Your Savings Grow. Your Future, Secure.

The Company's
401(k) Retirement Savings Plan

Our 401(k) plan lets you:

- Provide for your future conveniently and easily
- Control the amount you save and how it's invested
- Receive tax benefits *now* and as your money grows
- Qualify for matching contributions from the company

The sooner you start, the sooner your savings can start to grow.

Let us tell you how to get started today!

FOR MORE INFORMATION:

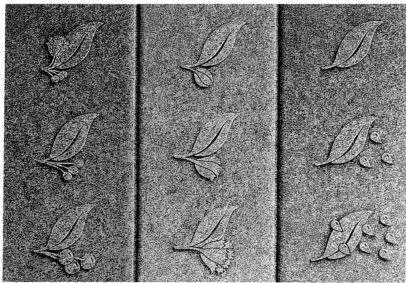

Investing in Stocks

If stocks perform so much better than bonds or Treasury bills, why doesn't everyone invest all their money in stocks? The answer is that stocks fluctuate more in value over the short term than other types of investments. In other words, investors must realize that along with the possible rewards of investing in the stock market comes added risk in the form of possible short term fluctuations in value.

Most experts strongly recommend that young investors invest a significant portion of their assets in stocks because they have the time to wait out the short term fluctuations in value. Even investors closer to retirement are usually encouraged to invest a portion of their assets in stocks in order to take advantage of the greater potential for growth.

You must decide how much "risk" you are comfortable with. You can invest some of your money in investment options that invest in bond funds or money market funds to reduce the risk of fluctuations in the value of your savings. However, you will also be giving up the potential for the higher returns that have historically been available only in the stock market. In addition, keep in mind that if you invest too conservatively, inflation may eat up a significant part of your investment returns.

Finding a balance between high returns on your investments with minimal fluctuations in the value of your account can be difficult. But, your plan helps by giving you the opportunity to spread your money among a number of options with different degrees of risk. Try the ones you are comfortable with now and remember that you can change your options as your needs change.

How does inflation affect my account?

Inflation is a silent partner in all your investments. Each year inflation reduces the purchasing power of your dollar. This means that your investments must earn at least as much as the rate of inflation just to stay even. For example, if the rate of inflation is 3% per year and you earn 5% on your investments, you have gained only 2% in terms of additional purchasing power. If you earn only 2% on your investments you are actually losing purchasing power.

Choosing your options

Now is the time to select your investment options. Put your plan contributions in the investment options that best meet your needs today. As your needs change, you can change the way your plan contributions are invested. Keep in mind that there is no "right answer" in selecting your options. Once you have made your selections, don't forget to congratulate yourself for taking this important step in providing for the growth of your future security.

1
Design Firm **Design Seven, Inc.**
Designer **Debbie Hayes/Bill Calder**
Illustrator **Bill Calder**
Client **The Adam Network**
Printing **4-color with varnish**

All illustrations, charts and textures created on the Mac using Adobe Photoshop.

34

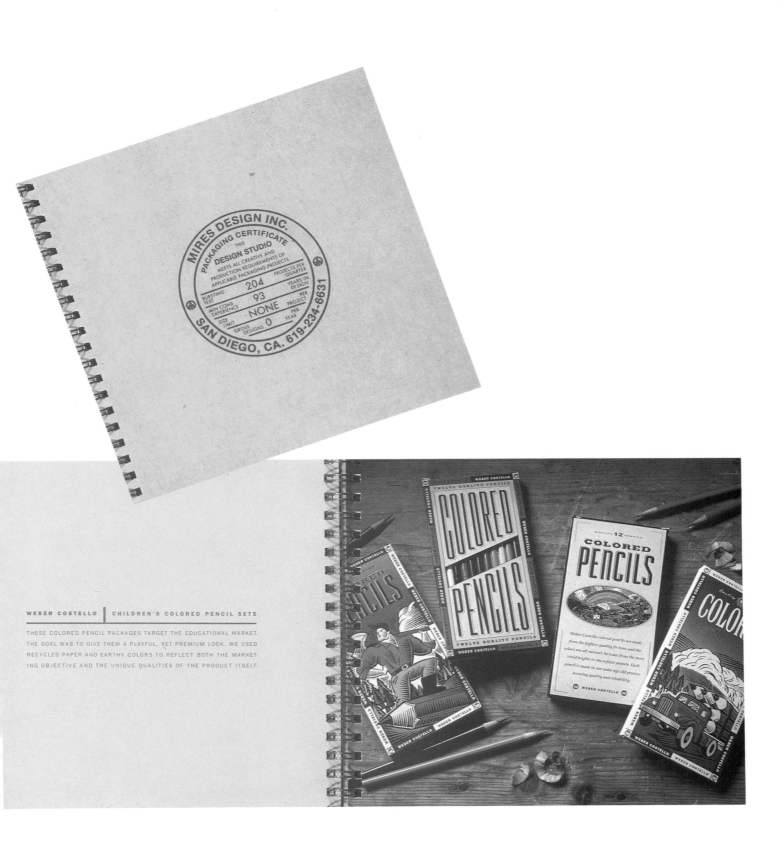

WEBER COSTELLO | CHILDREN'S COLORED PENCIL SETS

THESE COLORED PENCIL PACKAGES TARGET THE EDUCATIONAL MARKET.
THE GOAL WAS TO GIVE THEM A PLAYFUL, YET PREMIUM LOOK. WE USED
RECYCLED PAPER AND EARTHY COLORS TO REFLECT BOTH THE MARKET-
ING OBJECTIVE AND THE UNIQUE QUALITIES OF THE PRODUCT ITSELF.

Design Firm **Mires Design**
Art Director **José Serrano**
Designer **José Serrano**
Client **Mires Design, Inc.**
Tool **QuarkXPress**

*This piece uses E Flute cardboard, 4-color offset print-
ing and wire-o binding.*

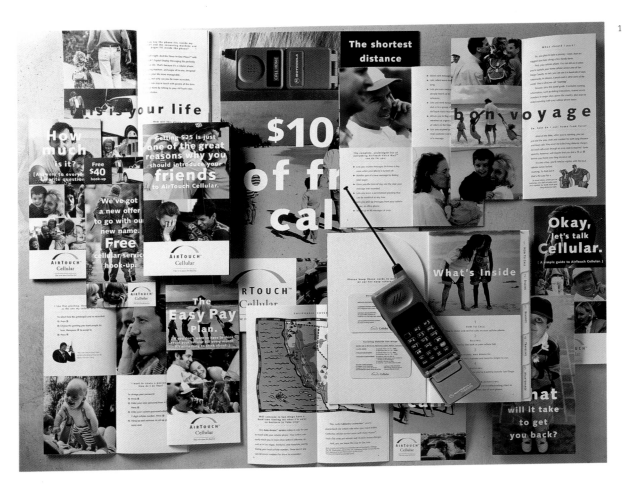

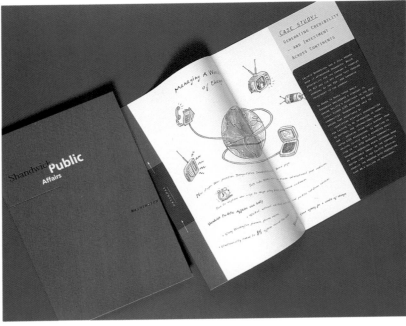

1
Design Firm **Mires Design**
Art Director **Scott Mires**
Designer **Scott Mires**
Illustrator **Tracy Sabin**
Photographer **Chris Wimpey**
Client **Airtouch Cellular**

2
Design Firm **Prospera**
Art Director **Karen Geiger**
Designers **Karen Geiger and Bettina Dehuhard**
Illustrator **Eric Hanson**
Copywriter **Shandwick Public Affairs**
Client **Shandwick Public Affairs**
Paper **Neenah Columns, French Newsprint, Potlatch, Vintage Velvet**
Tools **QuarkXPress and Adobe Illustrator**

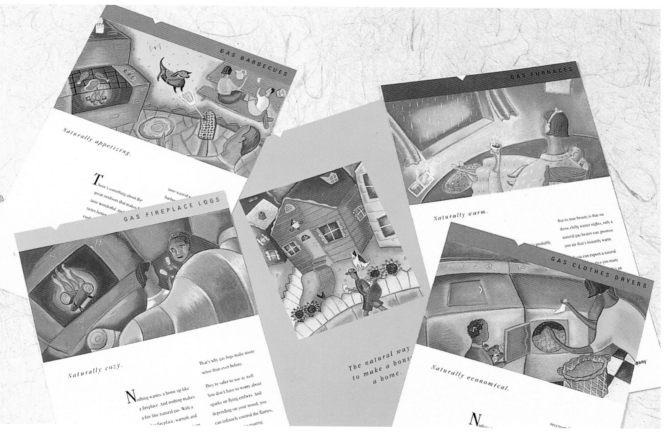

1

Design Firm **Mike Quon Design Office**
Illustrator **Mike Quon**
Client **Discover Card**

2

Design Firm **Julia Tam Design**
Art Director **Julia Chong Tam**
Designer **Julia Chong Tam**
Illustrator **Mercedes McDonald**
Copywriter **Peter Brown**
Client **Southern California Gas Company**
Printing **6-color on Lustro Recycled, die-cut folder
 with stair-step inserts**

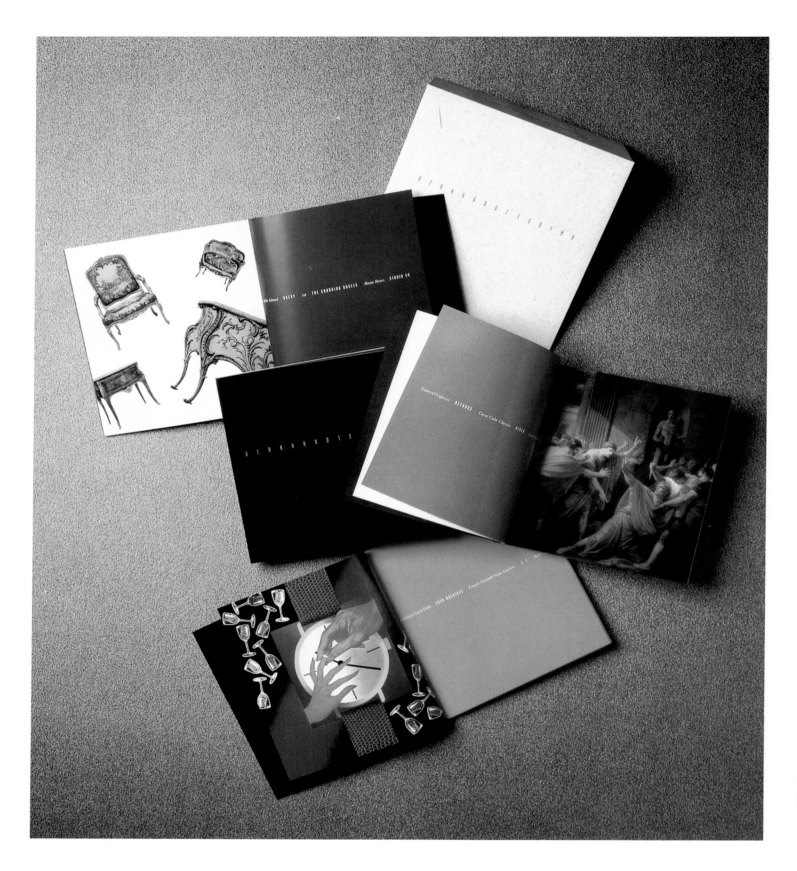

Design Firm **Bernhardt Fudyma Design Group**
Art Director **Craig Bernhardt, Janic Fudyma**
Designer **Iris Brown**
Copywriter **Bary Bohrer**
Client **Bernhardt Fudyma Design Group**

*Four process colors/two PMS colors and one dry pass of varnish on Strathmore
Grandee cover and Westvaco Inspirations text*

*This piece announces fifteen years in business. Everything in it relates in some
way to the number 15. Even the size of the brochure is 15 cm by 15 cm.*

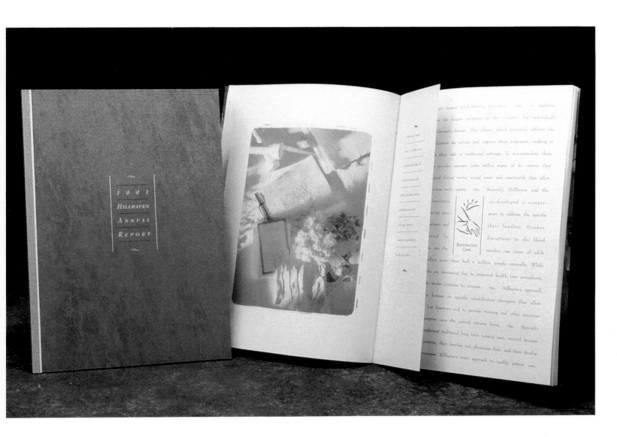

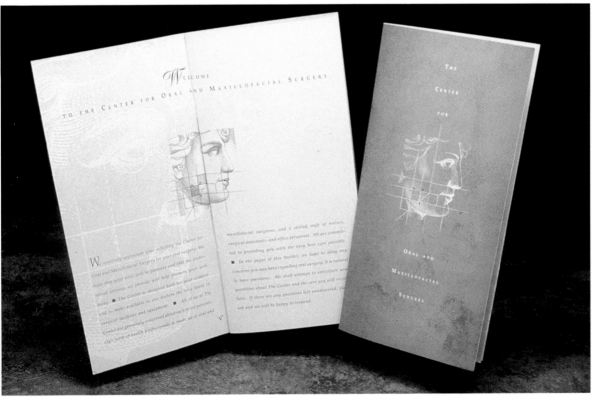

1
Design Firm **Hornall Anderson Design Works**
Art Director **Jack Anderson**
Designer **Jack Anderson, Mary Hermes**
Illustrator **Georgia Deaver**
Photographer **Darrell Peterson**
Copywriter **Tim Carroll**
Client **Hillhaven Corp.**

Six colors on Sundance Felt cover, Starwhite Vicksburg text

2
Design Firm **Hornall Anderson Design Works**
Art Director **Jack Anderson**
Designer **Jack Anderson, Brian O'Neill, Lian Ng**
Illustrator **John Fretz**
Copywriter **Dr. Clem Pellet**
Client **The Center for Oral and Maxillofacial Surgery**

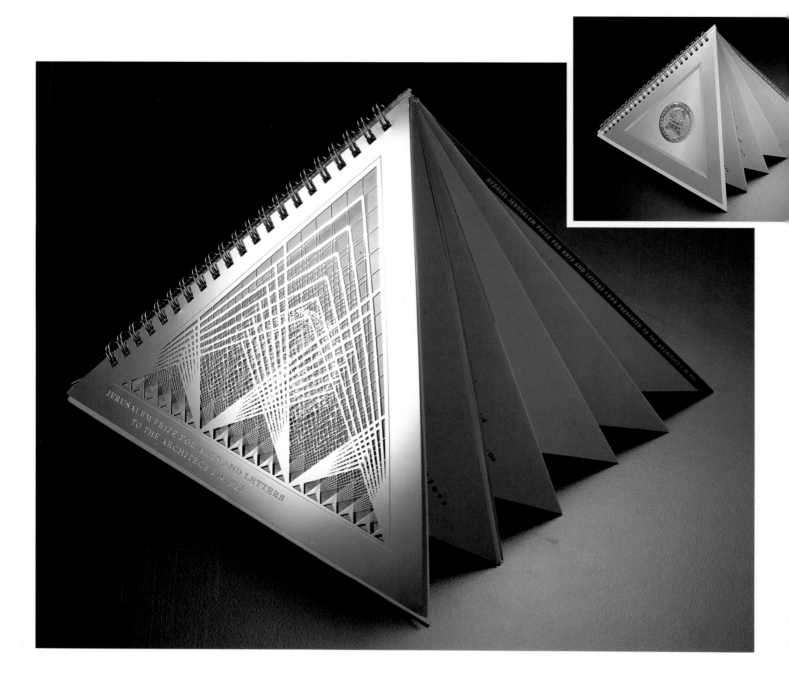

Design Firm **Visual Persuasion**
Art Directors **Roni Hecht, Aryeh Hecht**
Designers **Roni Hecht, Aryeh Hecht**
Illustrators **Roni Hecht, Aryeh Hecht**
Client **Friends of Bezalel Academy of Arts and Design**

Objective: To create a program for an architect's award ceremony that embodied a festive but architectural tone

Innovation: A spectacular program inspired by the pyramid at the Louvre, it mirrors this work of art when opened and uses its pages as structural "columns." Special tooling that binds the triangular pages was developed to compensate for the odd angles. An unusual grid/layout kept the work in budget; through careful planning and unconventional assembly, only two dies and three signatures were used. A chemically etched stainless steel cover that symbolized the architect's trademark "lace of steel" technique draws immediate attention.

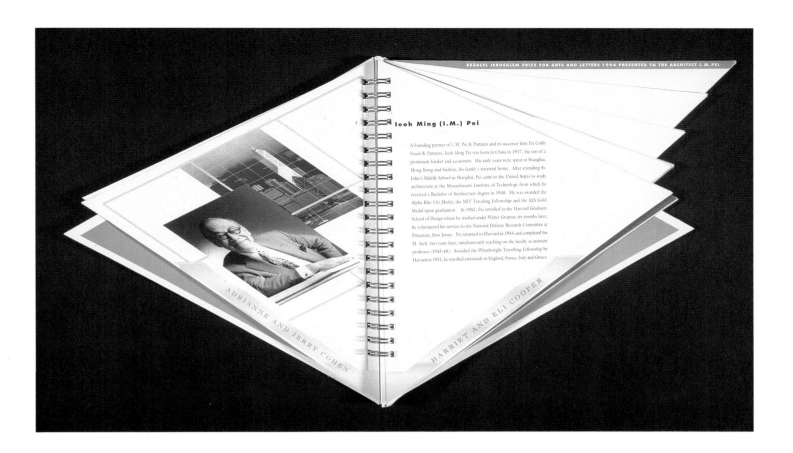

Ieoh Ming (I.M.) Pei

A founding partner of I. M. Pei & Partners and its successor firm Pei Cobb Freed & Partners, Ieoh Ming Pei was born in China in 1917, the son of a prominent banker and economist. His early years were spent in Shanghai, Hong Kong and Suzhou, his family's ancestral home. After attending St. John's Middle School in Shanghai, Pei came to the United States to study architecture at the Massachusetts Institute of Technology from which he received a Bachelor of Architecture degree in 1940. He was awarded the Alpha Rho Chi Medal, the MIT Traveling Fellowship and the AIA Gold Medal upon graduation. In 1942, Pei enrolled in the Harvard Graduate School of Design where he studied under Walter Gropius; six months later, he volunteered his services to the National Defense Research Committee at Princeton, New Jersey. Pei returned to Harvard in 1944 and completed his M. Arch. two years later, simultaneously teaching on the faculty as assistant professor (1945-48). Awarded the Wheelwright Travelling Fellowship by Harvard in 1951, he travelled extensively in England, France, Italy and Greece.

ADRIANNE AND JERRY COHEN

HARRIET AND ELI COOPER

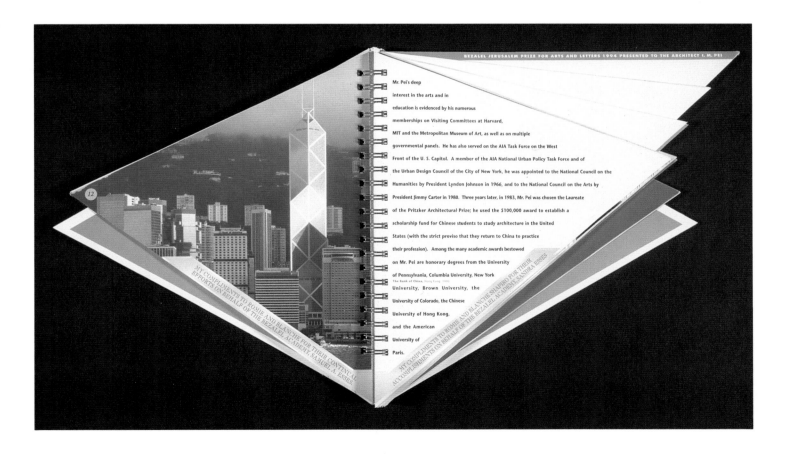

Mr. Pei's deep interest in the arts and in education is evidenced by his numerous memberships on Visiting Committees at Harvard, MIT and the Metropolitan Museum of Art, as well as on multiple governmental panels. He has also served on the AIA Task Force on the West Front of the U. S. Capitol. A member of the AIA National Urban Policy Task Force and of the Urban Design Council of the City of New York, he was appointed to the National Council on the Humanities by President Lyndon Johnson in 1966, and to the National Council on the Arts by President Jimmy Carter in 1980. Three years later, in 1983, Mr. Pei was chosen the Laureate of the Pritzker Architectural Prize; he used the $100,000 award to establish a scholarship fund for Chinese students to study architecture in the United States (with the strict proviso that they return to China to practice their profession). Among the many academic awards bestowed on Mr. Pei are honorary degrees from the University of Pennsylvania, Columbia University, New York University, Brown University, the University of Colorado, the Chinese University of Hong Kong, and the American University of Paris.

The Bank of China, Hong Kong, 1990

12

MY COMPLIMENTS TO ROMIE AND BLANCHE FOR THEIR CONTINUAL EFFORTS ON BEHALF OF THE BEZALEL ACADEMY. SAMUEL A. ESSES

MY COMPLIMENTS TO ROMIE AND BLANCHE SHAPIRO FOR THEIR ACCOMPLISHMENTS ON BEHALF OF THE BEZALEL ACADEMY. SANDRA ESSES

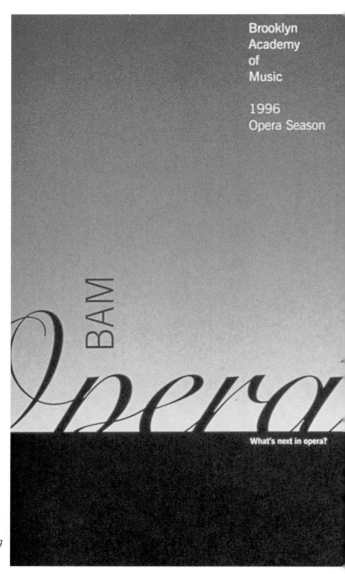

What's next in opera?

Design **Michael Bierut and Emily Hayes for Pentagram Design**
Project **Brooklyn Academy of Music opera brochure**
Client **Brooklyn Academy of Music**
Tools **QuarkXPress on Macintosh**
Font **Snell Roundhand**

The wide stripes partially conceal the type to suggest something coming over the horizon, a visual metaphor for the Festival's focus on emerging talent. Subsequent brochures use variations on this theme, incorporating script or simply cutting off lower parts of letters.

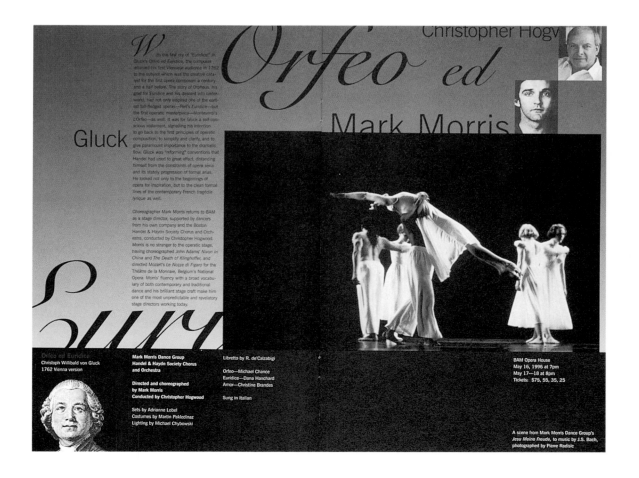

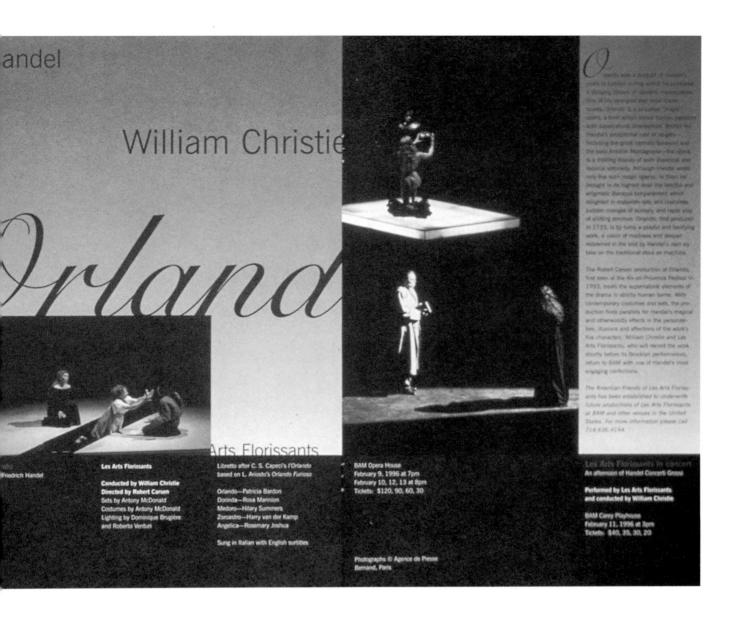

andel

William Christie

Orland

Arts Florissants

ado
Friedrich Handel

Les Arts Florissants

Conducted by William Christie
Directed by Robert Carsen
Sets by Antony McDonald
Costumes by Antony McDonald
Lighting by Dominique Brugière
and Roberto Venturi

Libretto after C. S. Capeci's l'Orlando
based on L. Ariosto's Orlando Furioso

Orlando—Patricia Bardon
Dorinda—Rosa Mannion
Medoro—Hilary Summers
Zoroastro—Harry van der Kamp
Angelica—Rosemary Joshua

Sung in Italian with English surtitles

BAM Opera House
February 9, 1996 at 7pm
February 10, 12, 13 at 8pm
Tickets: $120, 90, 60, 30

Les Arts Florissants in concert
An afternoon of Handel Concerti Grossi

**Performed by Les Arts Florissants
and conducted by William Christie**

BAM Carey Playhouse
February 11, 1996 at 3pm
Tickets: $40, 35, 30, 20

Photographs © Agence de Presse
Bernand, Paris

Design **Norman Moore for Design Art, Inc.**
Project **RCA Jazz catalog**
Client **RCA/BMG**
Tools **Adobe Photoshop, QuarkXPress on Macintosh**
Font **Degenerate**

This is a jazz catalog cover.

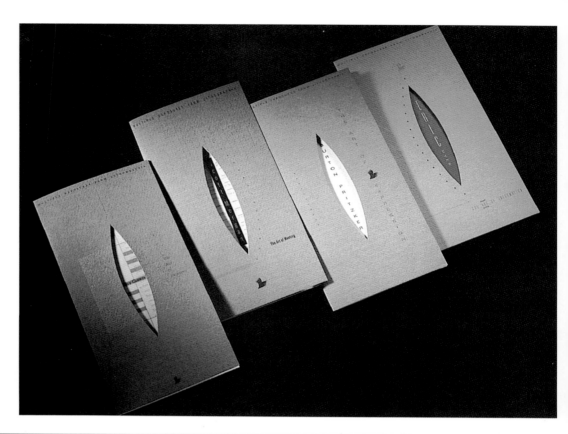

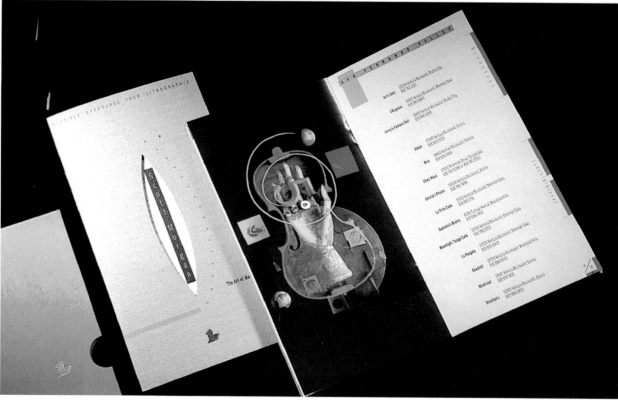

1
Design Firm **Vrontikis Design Office**
Art Director **Petrula Vrontikis**
Designer **Petrula Vrontikis/Kim Sage**
Photographer **Jeff Corwin/Burton Pritzker/**
 Eric Myer/Scott Morgan
Copywriter **Candice Pearson**
Client **Lithographix Inc.**
Printing **6-color on Gilbert Esse and**
 Consolidated Reflections

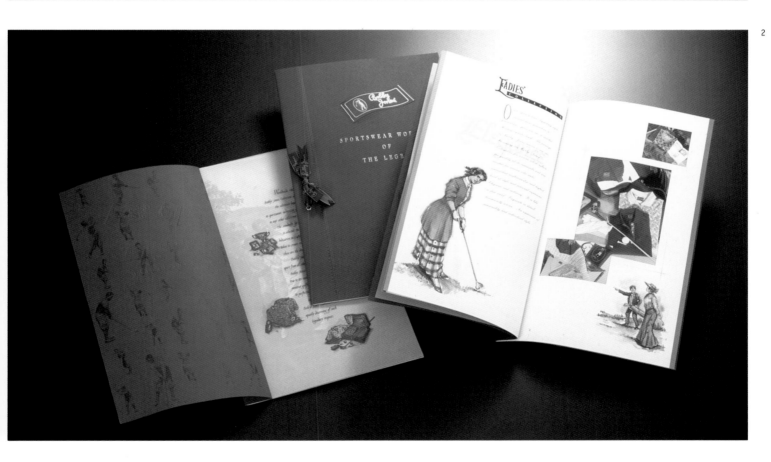

1
Design Firm **Grafik Communications, Ltd.**
Designers **Melanie Bass, David Collins, Judy Kirpich**
Photographers **Steve Biver, Heidi Neimala**
Copywriter **Jake Pollard**
Client **Karla Colletto Swimwear**
Paper/Printer **Quintescence, Virginia Lithograph**

1➤ *This brochure is hand collated and machine sewn in order to save costs. The use of fabric gives the binding a handmade appearance, and relates it to the cover photography, which features pieces of translucent fabric with colored lights.*

2➤ *This piece uses ribbon, embossing and hot-gold stamping to communicate an elite corporate image.*

2
Design Firm **Masterline Communications Ltd.**
Art Director **Grand So, Kwong Chi Man**
Designer **Kwong Chi Man, Grand So**
Illustrator **James Fong**
Photographer **David Lo**
Client **Ryoden Sports Trading Co., Ltd.**
Printer **Yiu Wah Offset Printing Co.**

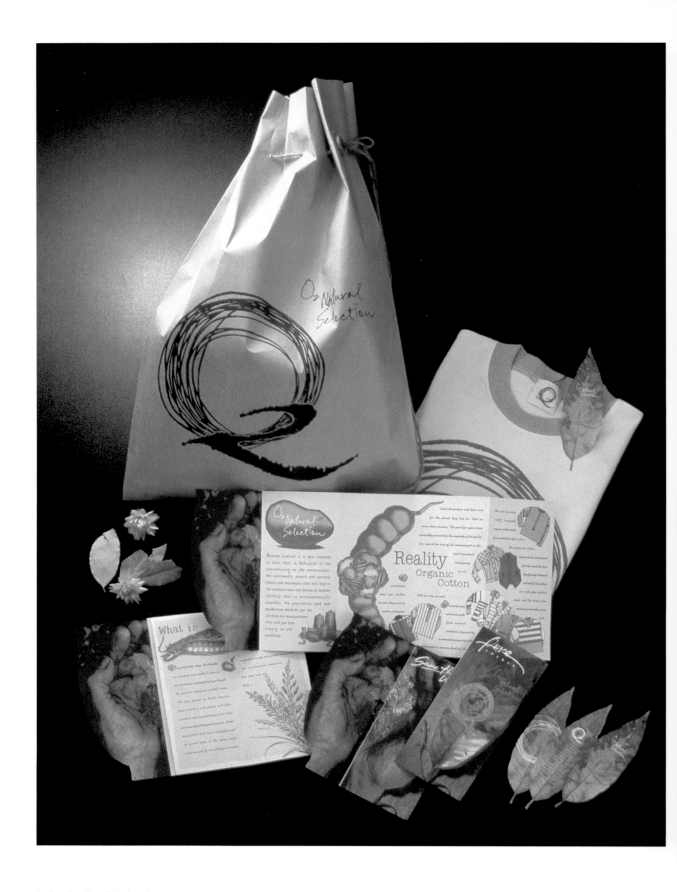

Design Firm **Grand Design Co.**
Art Directors **Grand So, Kwong Chi Man**
Designers **Kwong Chi Man, Grand So**
Illustrator **Martin Ng**
Photographer **Almond Chu**
Copywriter **Finny Maddess Consultants Ltd.**
Client **Sureap Ltd.**
Printer **Reliance Production**

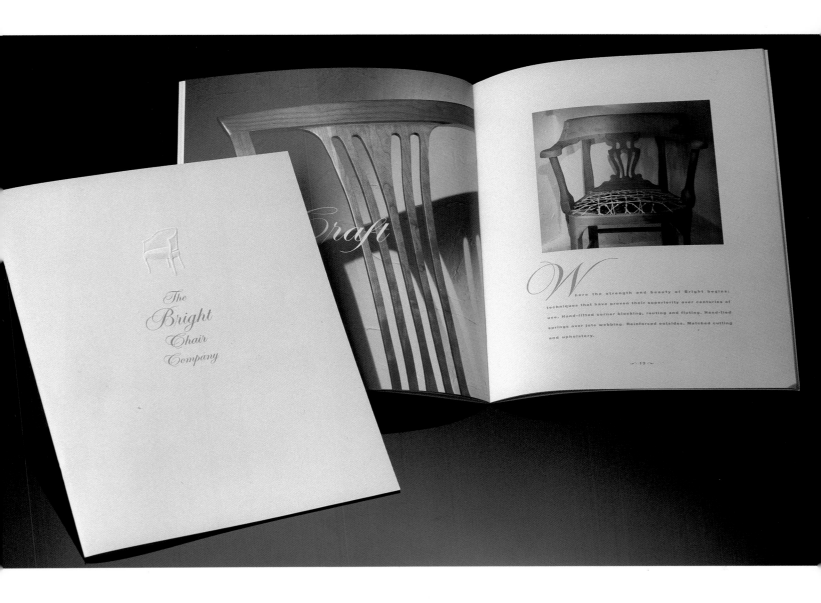

Design Firm **Diana Howard Design**
Art Director **Diana Howard**
Designer **Diana Howard**
Photographer **Deborah Klesenski**
Copywriter **Paul Stiga**
Paper/Printer **Vintage Cream, Quintessence Woods
 Lithographics**
Tool **QuarkXPress**

*The brochure uses old-style photo lettering. The main
challenge the designer faced was finding a tinted
varnish to match the color of the paper.*

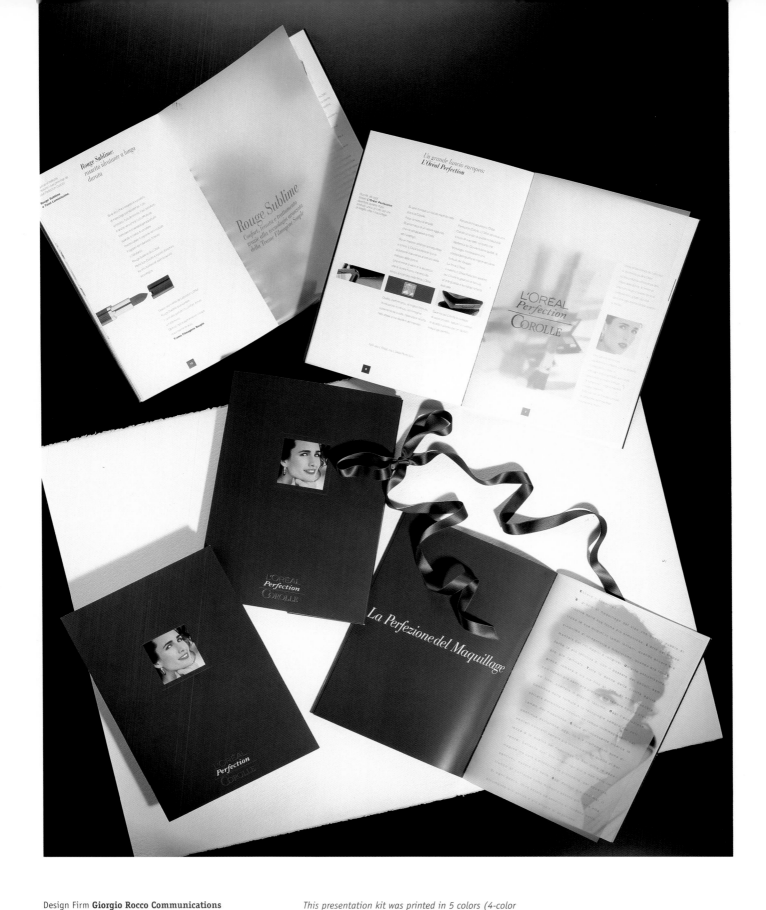

Design Firm **Giorgio Rocco Communications**
 Design Consultants
Art Director **Giorgio Rocco**
Designer **Giorgio Rocco**
Photographer **Archives L'Oréal**
Copywriter **Anna Andreuzzi**
Client **L'Oréal**
Paper/Printer **Zanders Matte Paper 167 lb.**
Tools **Macromedia FreeHand, and Adobe PageMaker**

This presentation kit was printed in 5 colors (4-color process and a single spot color) on matte and transparent papers. We used matt plastification, embossing, and hot gold on the covers. Actress Andie MacDowell provided the testimonial.

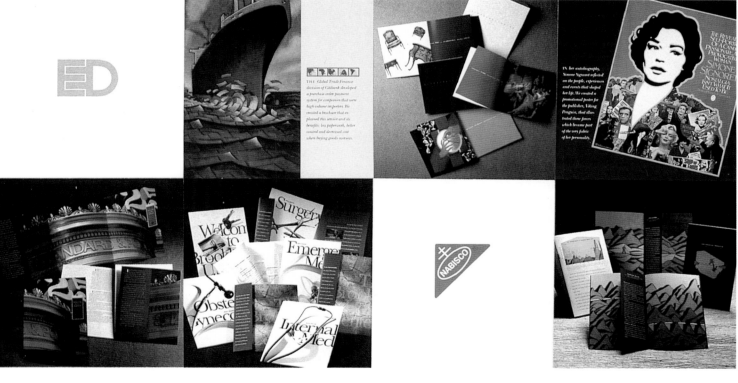

1
Design Firm **Carol Lasky Studio**
Art Director **Carol Lasky**
Designer **Laura Herrmann**
Illustrator **Sergio Baradat**
Photographer **Dana Mills**
Copywriter **Carol Lasky**
Client **Self Promotion**
Printing **3-color on Mohawk Splendorlux (cover)
and 2-color on Appleton Jazz (Text) and 4-color
label on cover.**

2
Design Firm **Bernhardt Fudyma Design Group**
Art Director **Craig Bernhardt/Janice Fudyma**
Designer **Bernhardt Fudyma Design Group**
Client **Bernhardt Fudyma Design Group**
Printing **Individual pages were printed on the "waste
area" of client's jobs, so colors and paper stocks
were determined by those jobs. BFDG has been
accumulating pages over 3 years and binds the
books themselves.**

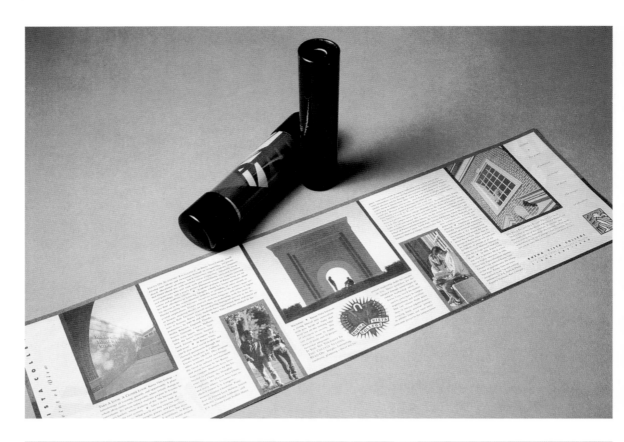

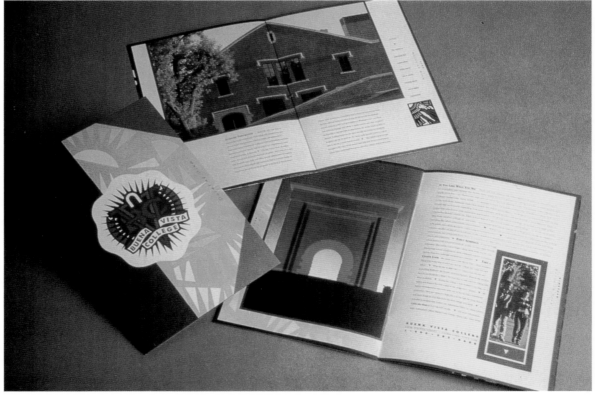

1
Design Firm **Sayles Graphic Design**
Art Director **John Sayles**
Designer **John Sayles**
Photographer **Bill Nellans**
Copywriter **Mary Langen-Goldstien**
Client **Buena Vista College**

Four colors on James River

Sent in a clear plastic tube, this mailer's "point of view" theme is revealed by a custom kaleidoscope with the Buena Vista logo inside.

2
Design Firm **Sayles Graphic Design**
Art Director **John Sayles**
Designer **John Sayles**
Illustrator **John Sayles**
Photographer **Bill Nellans**
Copywriter **Wendy Lyons**
Client **Buena Vista College**

Four colors on James River

The paper used for this project is specially made by the James River paper mill. John Sayles developed the paper color with mill representatives and was able to specify the finish, color of flocking, etc.

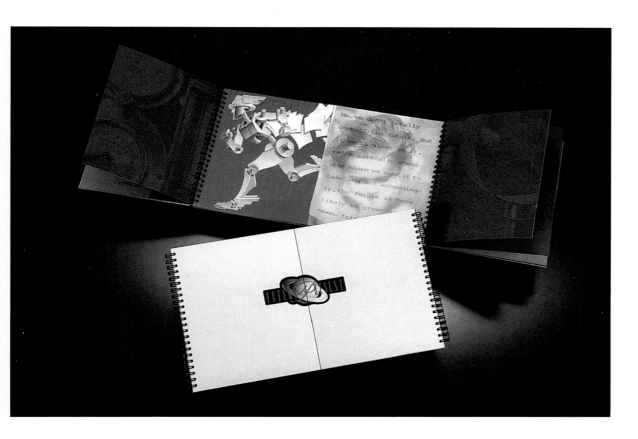

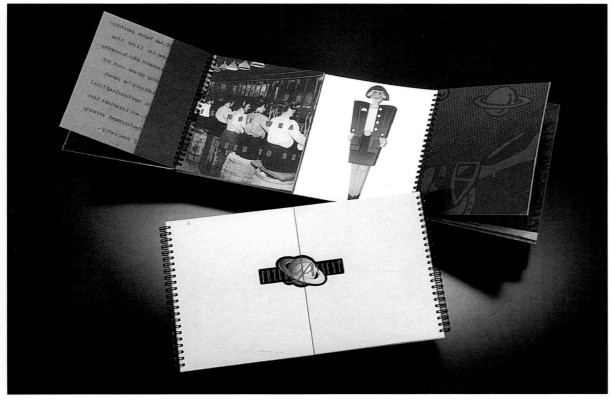

1
Design Firm **Vaughn Wedeen Creative**
Art Directors **Steve Wedeen/Rick Vaughn**
Designer **Steve Wedeen**
Illustrators **D. Tillinghast/D. Jonason**
Copywriters **Nathan James/Richard Kuhn/**
 Steve Wedeen
Client **US West Communications**
Printing **Gilbert Esse White Smooth Cover, Matte**
 Calendered Rigid Clear Vinyl

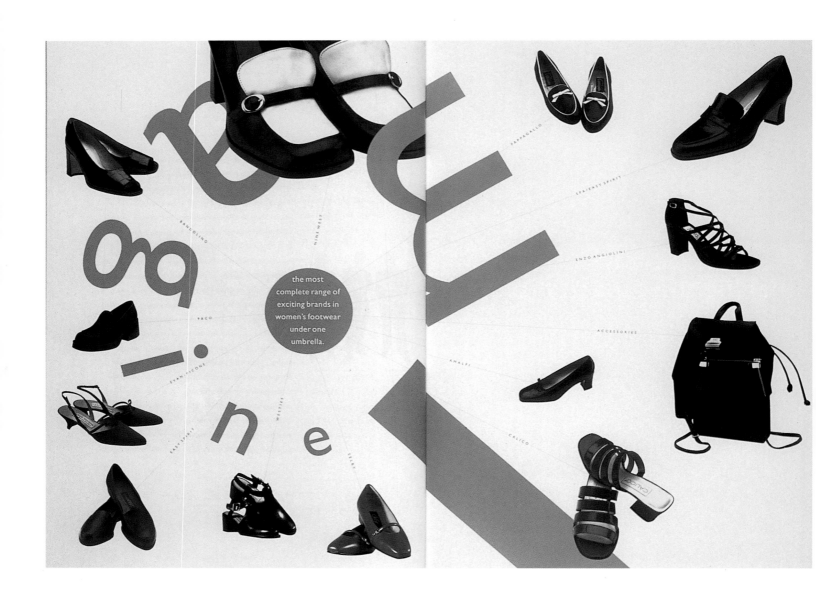

the most complete range of exciting brands in women's footwear under one umbrella.

Imagine the capacity to do it, do it right, and do it right now.

Design **James K. Brown for Pentagram Design**
Project **Nine West 1995 annual report**
Client **Nine West Group, Inc.**
Tools **Adobe Illustrator, QuarkXPress**
Fonts **Gill Sans**

Nine West Group is a leading designer, developer, and marketer of women's fashion footwear. The cover presents an image that is focused toward the future. Bold and imaginative typographic treatments emphasize the company's success in understanding and meeting the needs of its customers.

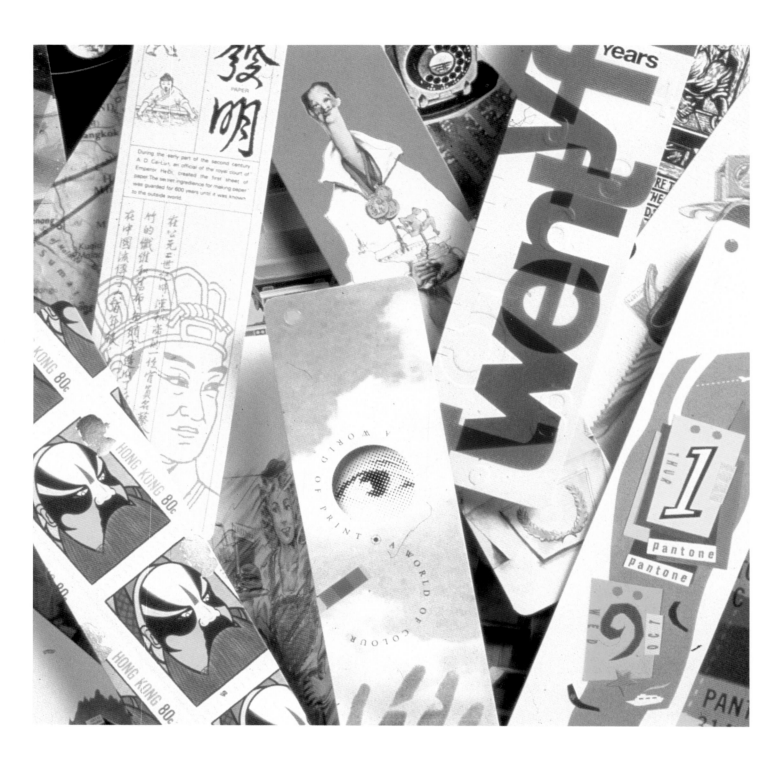

Design Firm **PPA Design Limited**
Art Director **Byron Jacobs**
Designers **Byron Jacobs, Chris Chan**
Illustrators **Percy Chung, Robin Whyler**
Printer **Sing Cheong Printing Co. Ltd.**
Client **Sing Cheong Printing Co. Ltd.**

Objective: To create a capabilities brochure that clearly communicates the attributes and services of the company

Innovation: The imaginative structure of the brochure resembles the format of an ink swatch book. Each panel illustrates a particular client attribute or service. In addition to the creative concept and bold visuals, multiple printing and finishing effects show the level of Sing Cheong's printing quality.

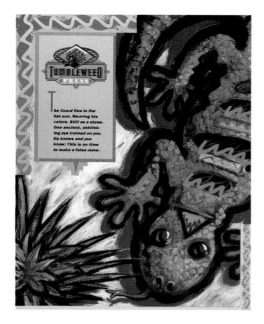

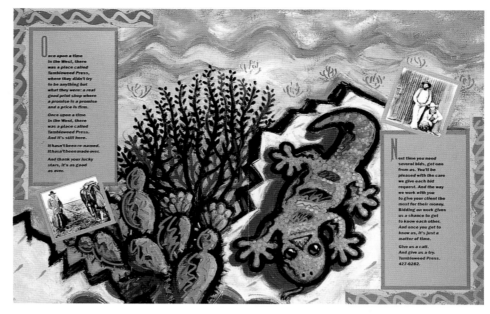

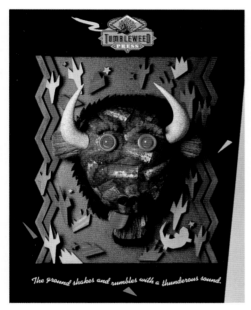

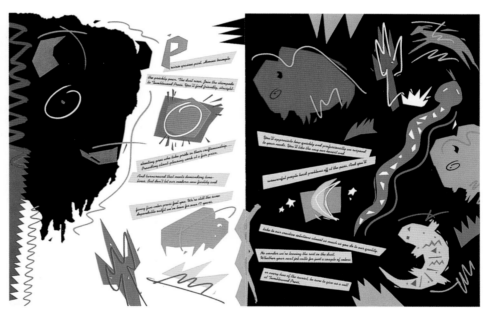

1
Design Firm **Lee Reedy Design Associates, Inc.**
Art Director **Lee Reedy**
Designer **Lee Reedy**
Illustrator **Mathew McFarren**
Photographer **Ron Coppock**
Copywriter **Ginny Hoyle**
Client **Tumbleweed Press**

Ten colors and varnish on LOE

2
Design Firm **Lee Reedy Design Associates Inc.**
Art Director **Lee Reedy**
Designer **Lee Reedy**
Illustrator **Lee Reedy, Heather Barlett, Jerry Simpson**
 (cover art)
Photographer **Roger Reynolds**
Client **Tumbleweed Press**

Nine colors on LOE

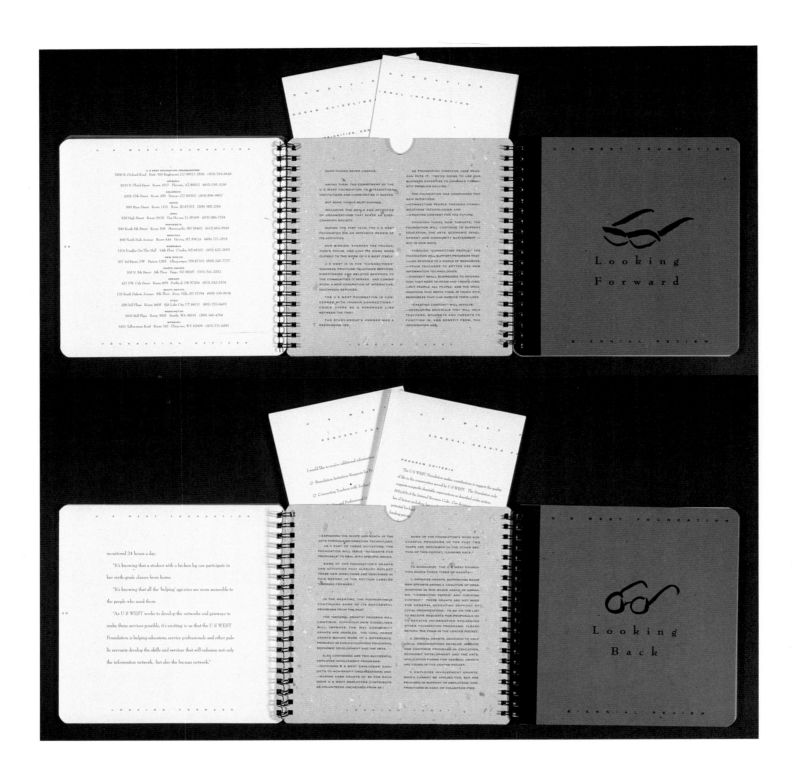

Design Firm **Vaughn Wedeen Creative**
Art Director **Steve Wedeen**
Designer **Steve Wedeen**
Illustrator **Vivian Harder**
Copywriter **Don Riggenbach**
Client **U S West Foundation**

Objective: To summarize the accomplishments and expenditures of the foundation for the previous two years and set the groundwork for guidelines in the years ahead

Innovation: Its childlike illustrations and small, 7-by-7-inch size give this report a friendly, storybook feel. Dual wire binding accentuates the two-books-in-one concept, and the two front covers ("Looking Forward" and "Looking Back") are black thermograph on Confetti cover and french folded. A center pocket, which gives the two books their backbone, also houses application forms.

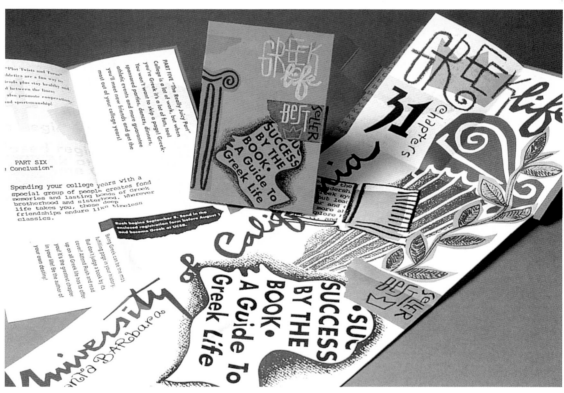

1
Design Firm **Metalli Lindberg Advertising**
Art Director **Stefano Dal Tin/Lionello Borean**
Designer **Stefano Dal Tin/Lionello Borean**
Client **GFU Italia (cultural association)**
Printing **2-color on Fedrigoni paper**

2
Design Firm **Sayles Graphic Design**
Art Director **John Sayles**
Designer **John Sayles**
Illustrator **John Sayles**
Copywriter **Wendy Lyons**
Client **University of California, Santa Barbara**
Printing **4-color plus varnish on Hopper Cardigan
(text) Chipboard**

*A combination brochure and poster, this multilayered
mailing arrives in a chipboard "book jacket." As the
piece is read, it unfolds to reveal a poster and the
"Success By The Book" name.*

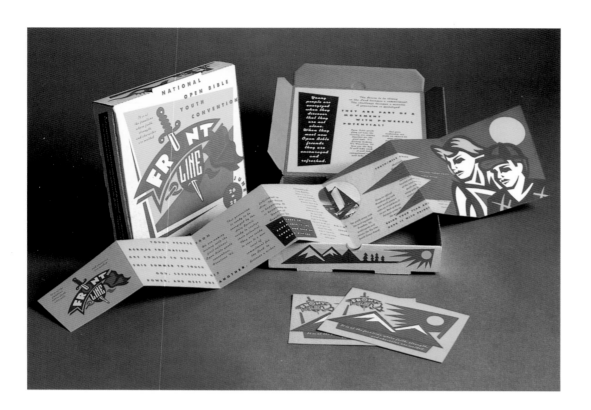

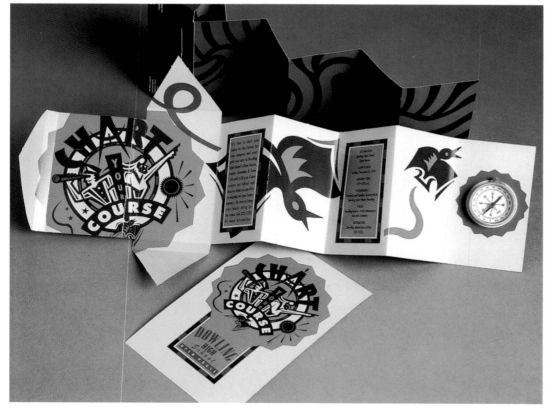

1
Design Firm **Sayles Graphic Design**
Art Director **John Sayles**
Designer **John Sayles**
Illustrator **John Sayles**
Copywriter **Wendy Lyons**
Client **Open Bible Churches**

Four colors on James River Tuscan

*Mailed in a corrugated box, this promotion for a national
youth convention features an unusually shaped brochure and
postcards.*

2
Design Firm **Sayles Graphic Design**
Art Director **John Sayles**
Designer **John Sayles**
Illustrator **John Sayles**
Copywriter **Carol Mouchka**
Client **Dowling High School**

Three colors on King James

*A custom die-cut allows this brochure to become its own
envelope. The "Chart Your Course" them was underscored
with a compass glued to the last panel in the mailing.*

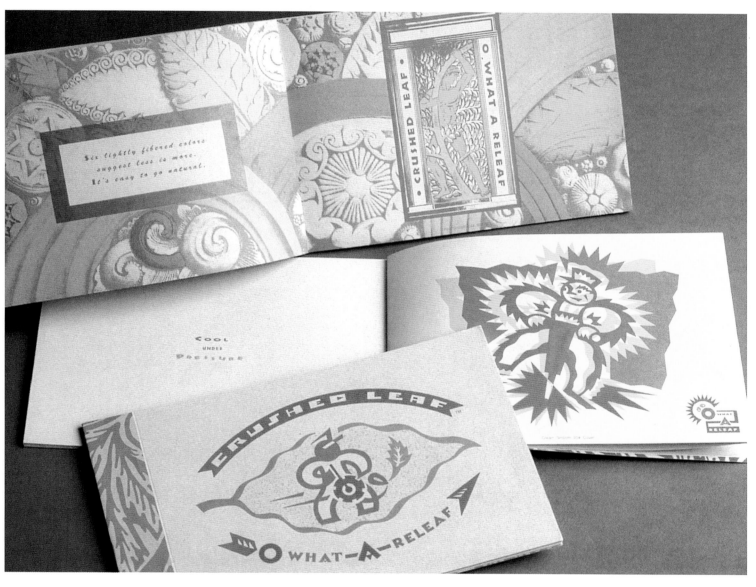

1
Design Firm **Metalli Lindberg Advertising**
Art Director **Stefano Dal Tin**
Designer **Lionello Borean**
Client **Felis Felix srl**
Printing **Recycled Paper**

2
Design Firm **Sayles Graphic Design**
Art Director **John Sayles**
Designer **John Sayles**
Illustrator **John Sayles**
Client **Howard Paper**
Printing **5-color on Howard Paper Crushed Leaf**
 (cover and text)

1
Design Firm **Bernhardt Fudyma Design Group**
Art Director **Craig Bernhardt/Janice Fudyma**
Designer **Janic Fudyma**
Illustrator **Kinuko Craft**
Copywriter **Stan Hironaka**
Client **Citicorp**

Four process colors/one PMS color

2
Design Firm **Bernhardt Fudyma Design Group**
Art Director **Craig Bernhardt, Janice Fudyma**
Designer **Iris Brown, Janice Fudyma**
Photographer **Lynn Sugarman**
Client **Kidder Peabody**

Four process colors/one PMS color, tinted varnish

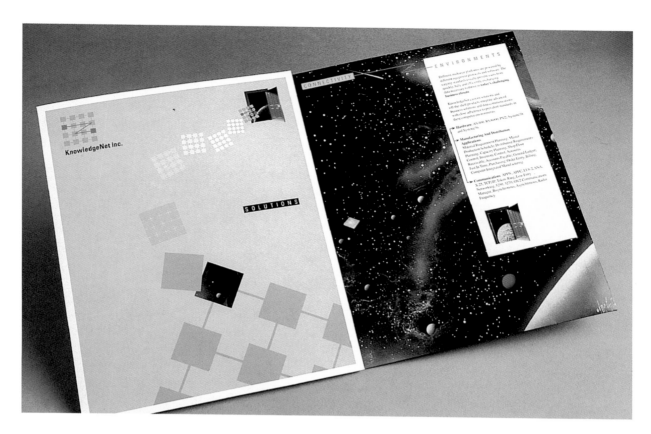

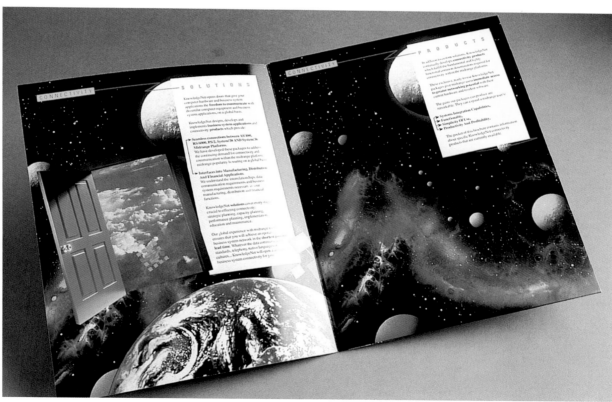

1
Design Firm **PGM, Inc.**
Art Director **Francis E. Shimandle**
Designer **Mike Pantuso**
Photographer **Stock Photography**
Copywriter **Robert Stein**
Client **KnowledgeNet, Inc.**
Printing **5-color on Enamel Cover, die-cut pocket for inserts**

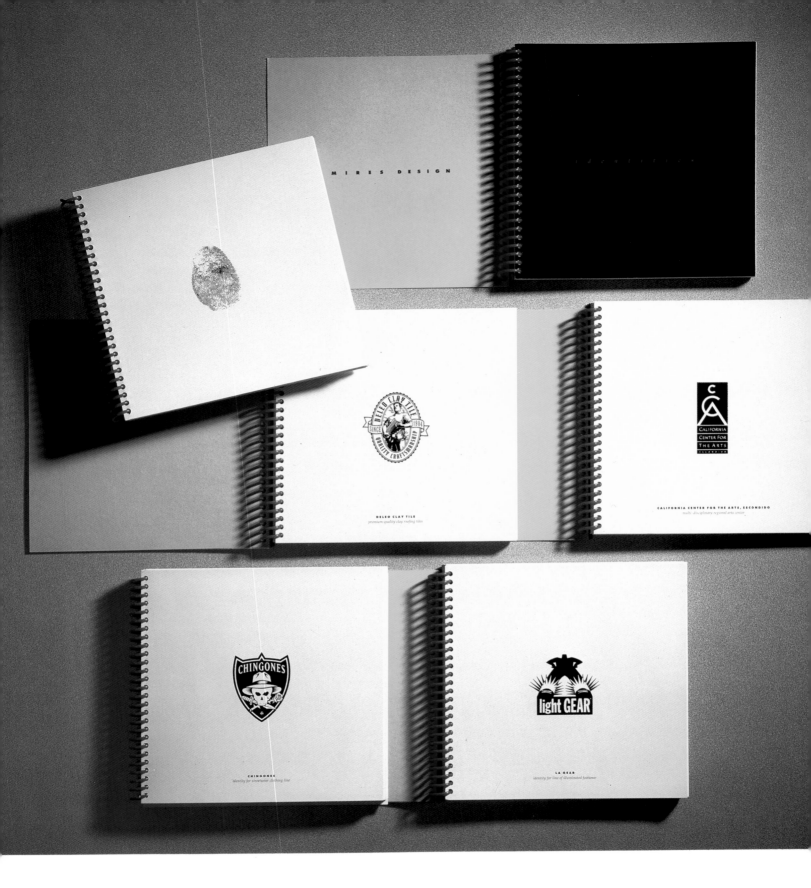

Design Firm **Mires Design, Inc.**
Art Director **José Serrano**
Designers **José Serrano, Deborah Fukushima**
Client **Mires Design, Inc.**

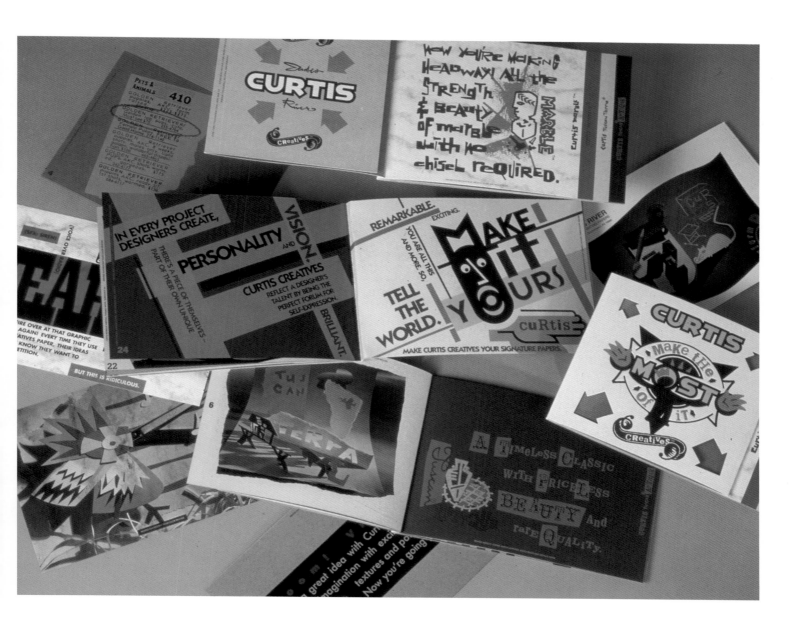

Design Firm **Sayles Graphic Design**
Art Director **John Sayles**
Designer **John Sayles**
Illustrator **John Sayles**
Copywriter **Wendy Lyons**
Client **James River, Curtis Fine Papers**
Paper/Printer **Curtis Papers, Columbia Graphics**

This unique brochure promotes Curtis Creatives line; catchy sub-themes such as "Make it Snappy," "Make it Up," and "Make it Yours" echo the brochure's fun theme. For example, inside the brochure, a colorful paper bird with a scissor beak illustrates how Curtis Creatives "make it sing."

Design Firm **Mires Design**
Art Director **John Ball**
Designers **John Ball and Gale Spitzley**
Client **California Center For The Arts Museum**
Tools **QuarkXPress and Adobe Illustrator**

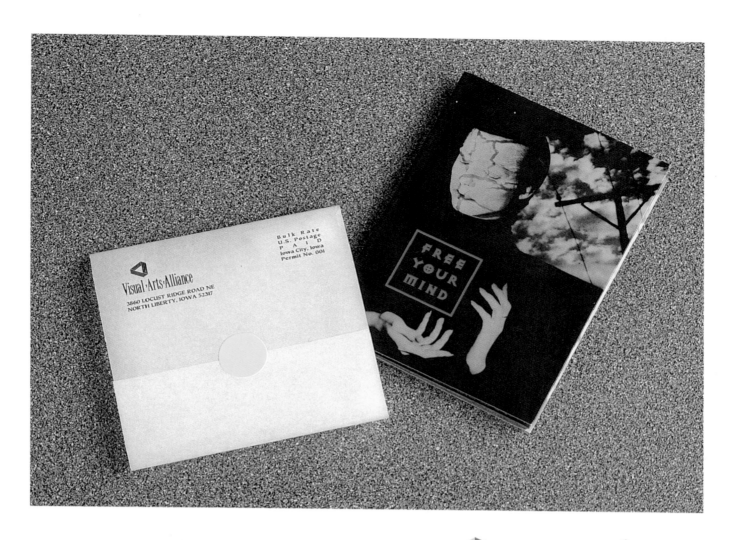

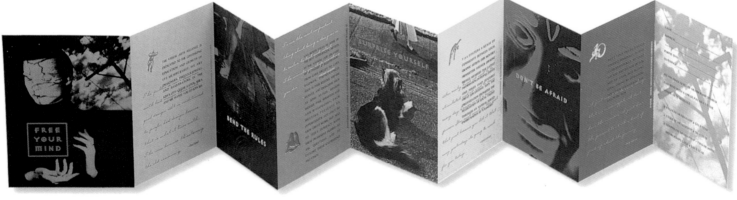

1
Designer **Renee Kremer and Kimberly Cooke**
Photographer **Mark C. Hartley/Jon Durant**
Copywriter **Kimberly Cooke**
Client **Visual Arts Alliance**
Printing **5-color PMS, Karma, UV Ultra Wrapper**

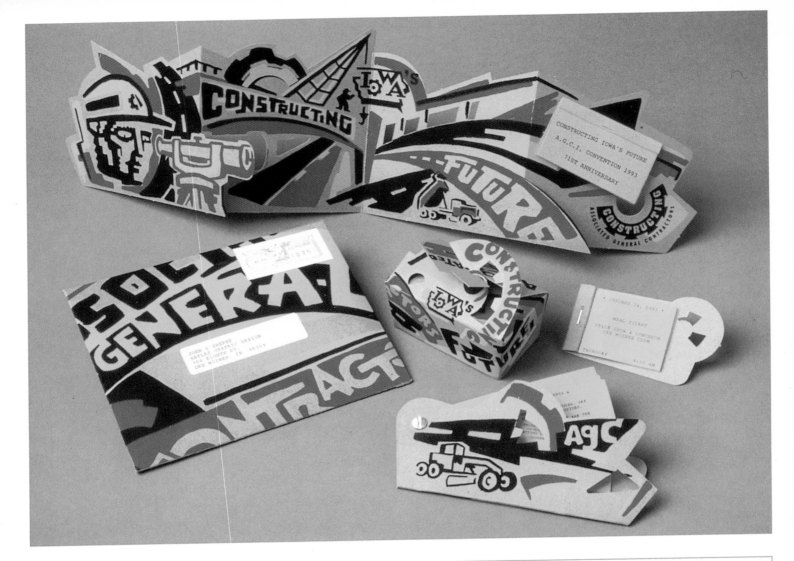

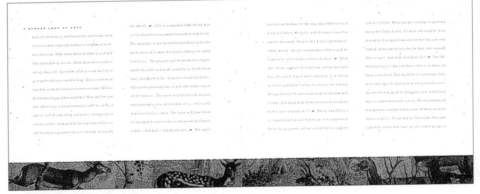

1
Design Firm **Sayles Graphic Design**
Art Director **John Sayles**
Designer **John Sayles**
Illustrator **John Sayles**
Copywriter **LuAnn Harkins**
Client **Associates General Contractors**
Printing **3-color on Chipboard Astrobrite Kraft
 Paper and Chipboard**

*Features multiple die-cuts and a small brochure
adhered to the end panel.*

2
Design Firm **SullivanPerkins**
Art Director **Ron Sullivan**
Designer **Dan Richards**
Illustrator **Dan Richards**
Copywriter **CETV**
Client **Conservationists for Educational Television**
Printing **2-color on Champion Benefit, bound with a twig**

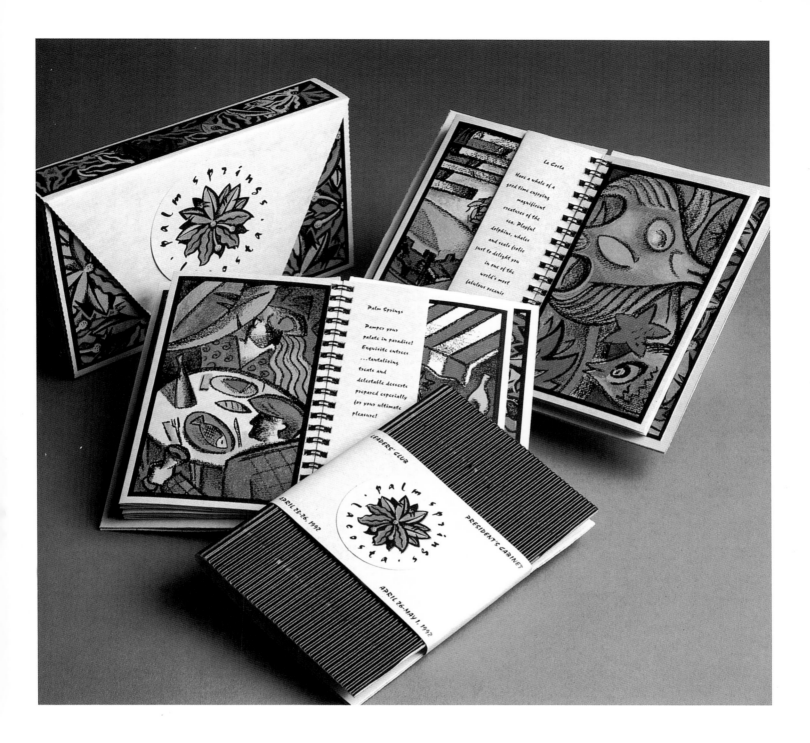

Design Firm **Sayles Graphic Design**
Art Director **John Sayles**
Designer **John Sayles**
Illustrator **John Sayles**
Copywriter **Wendy Lyons**
Client **Central Life Assurance**

Four colors on James River Graphika Parchment

*Because a limited number of brochures were required,
this project was silk-screened. The spiral-bound piece
features a corrugated cover and is mailed in a box-like
envelope.*

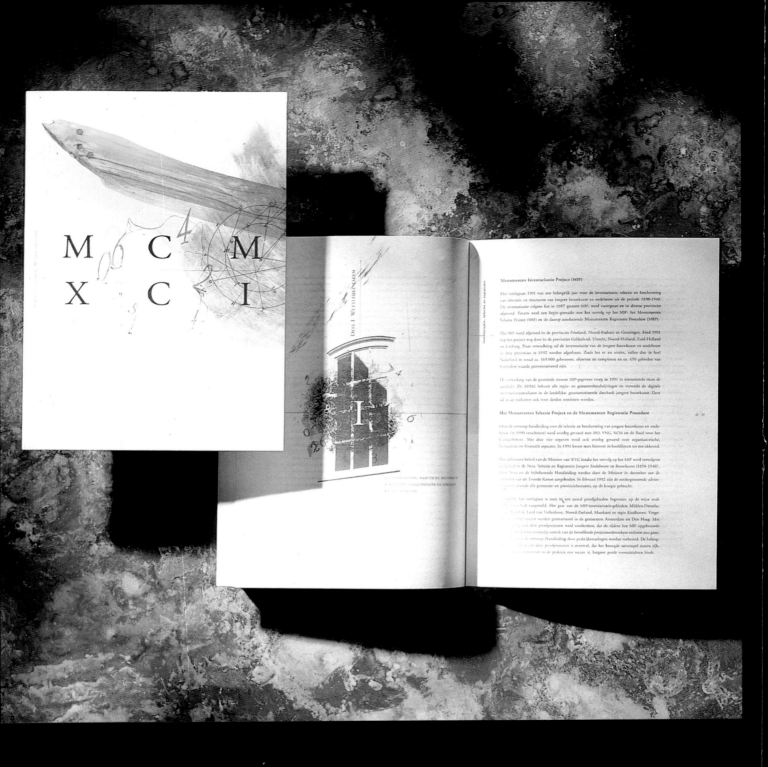

1
Design Firm **Keja Donia Design**
Art Director **Eric Nuijten**
Photographer **Robert Shackleton,**
 Rijksdienst voor de Monumentenzorg
Copywriter **Mr. R. Berends,**
 Rijksdienst voor de Monumentenzorg
Client **Rijksdienst voor de Monumentenzorg**
Printing **4-color**

Annual report for the Dutch Historic Buildings Society

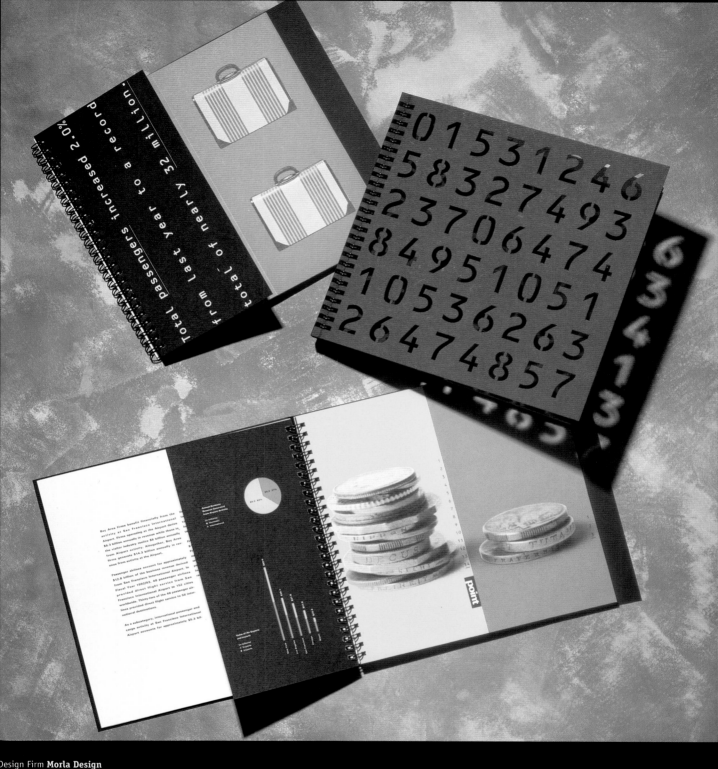

Design Firm **Morla Design**
Art Director **Jennifer Morla**
Designers **Jennifer Morla, Craig Bailey**
Photographer **Holly Stewart**
Client **San Francisco Airport Commission**

*Objective: To produce an annual report that reflects an airport's
economic impact on the area*

*Innovation: A set of punched-out numerals on a cover page and
each chapter's key financial figure displayed prominently create a
dramatic visual. Readers browsing through the report can easily*

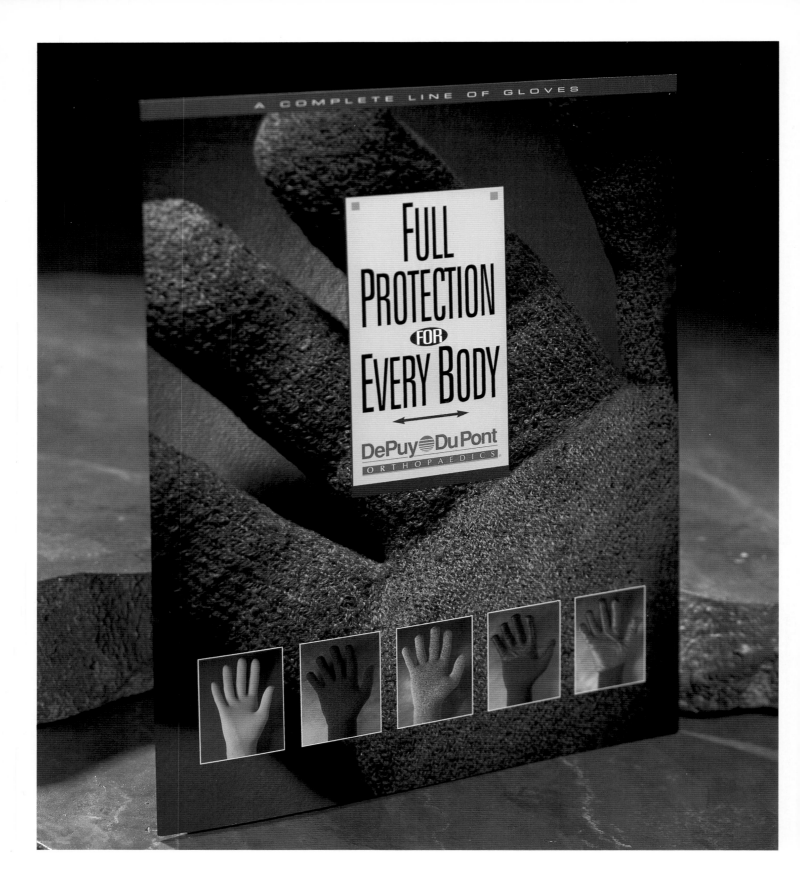

Design Firm **Held Diedrich**
Art Director **Dick Held**
Photographer **Partners Photograph**
Copywriter **Linda Lazier**
Client **DePuy DuPont Orthopaedics**
Paper/Printer **EPI**
Tools **QuarkXPress**

DePuy Dupont Orthopaedics offers a line of protective gloves made with Kevlar (the same material commonly used for bulletproof vests). The designers bring attention to the line by employing macrophotography of one of the gloves in the brochure. The backdrops for photography were hand-painted.

Design **Carlos Segura for Segura, Inc.**
Project **1996 XXX Snowboards catalog cover**
Client **XXX**
Tools **Adobe Illustrator, Adobe Photoshop, QuarkXPress**
Font **Proton**

*This year, the catalog took the shape of a trip diary, planner, calendar,
snowboard tips and ethical guidelines, travel information, and resort,
car, and airline 800 numbers.*

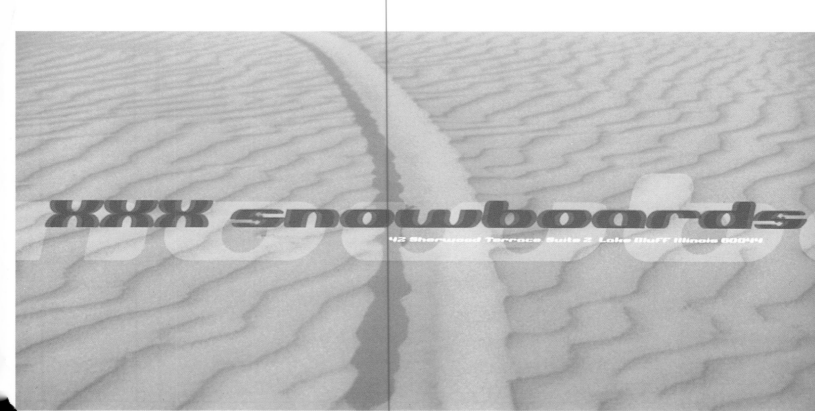

Design **Mark Drury for International Events**
Project **Networkers 1996**
Client **Cisco Systems, Inc.**
Tools **Adobe Illustrator on Macintosh**
Font **Template Gothic**

The font was outlined and manipulated in Illustrator. A rough body or inner weight was drawn with the Wacom tablet, giving the logo several layers.

Australia
Europe
Singapore
Japan
South Africa
Latin America
USA
Canada

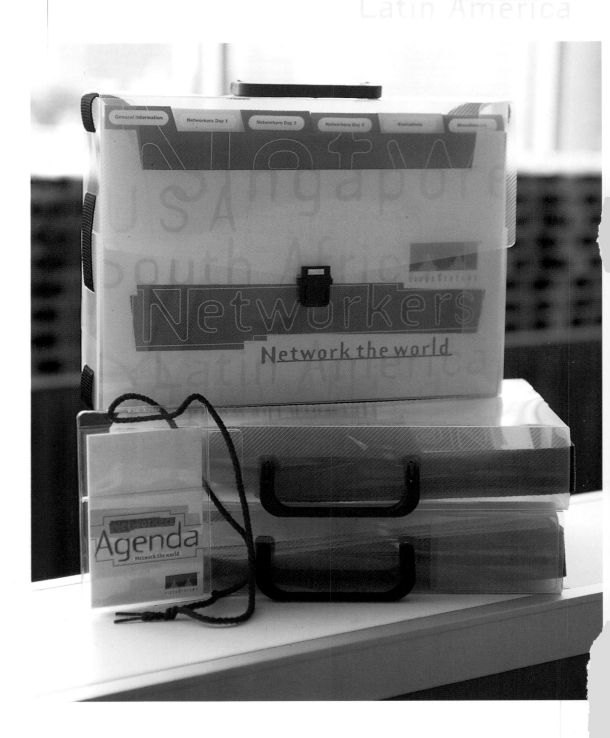